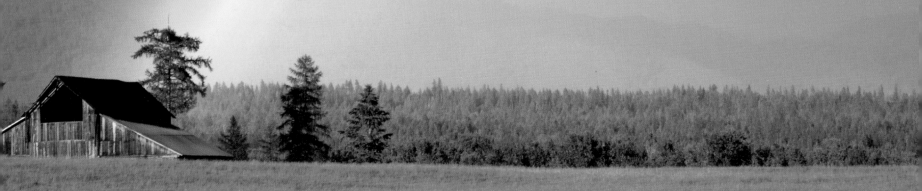

CHUCK HANEY

BIG SKY BARNS

Grand and Historic Barns of Montana

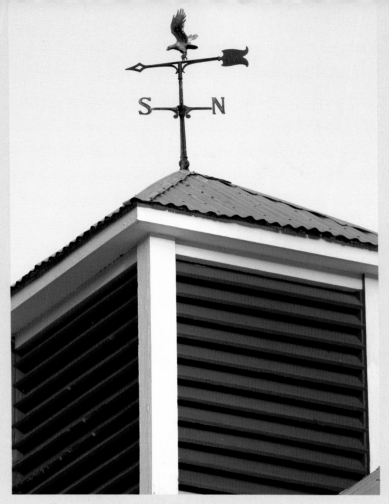

ABOVE: *Eagle weather vane, the Bigfork barn*

FRONT COVER: *The historic "Round Barn" of Twin Bridges*

TITLE PAGE: *Rainbow over a Whitefish barn*

FACING PAGE: *A springtime view of a cattle barn near the Two Medicine River, with Glacier National Park and a railroad trestle in the background*

BACK COVER: *Some observers see a surprised face on this dairy/ stock barn (circa 1897) on the Tutvedt Farm near Kalispell*

ABOUT THE PHOTOGRAPHER

Chuck Haney is a full time professional freelance photographer/writer based in Whitefish, Montana. Chuck travels throughout the West and Midwest of the U.S. and Canada in pursuit of interesting subjects. His landscapes, agriculture, and outdoor sports photos/articles have been published in numerous national and regional publications.

Chuck photographs things he enjoys passionately doing, such as hiking, bicycling, canoeing, and appreciating the land— the latter a result of his rural upbringing on an Ohio farm.

Big Sky Barns is Chuck's ninth book. In addition, Chuck is the sole photographer for several calendars. He also teaches photography workshops each summer and autumn. For more information on Chuck's work, visit www.chuckhaney.com.

Copyright © 2007 by Chuck Haney
Published by Riverbend Publishing, Helena, Montana
1 2 3 4 5 6 7 8 9 0 SI 12 11 10 09 08 07 06
Printed in South Korea.

Cover & text design by DD Dowden
ISBN 10: 1-931832-75-7
ISBN 13: 978-1-931832-75-5

RIVERBEND PUBLISHING
P.O. Box 5833
Helena, MT 59604
Toll-free 1-866-787-2363
www.riverbendpublishing.com

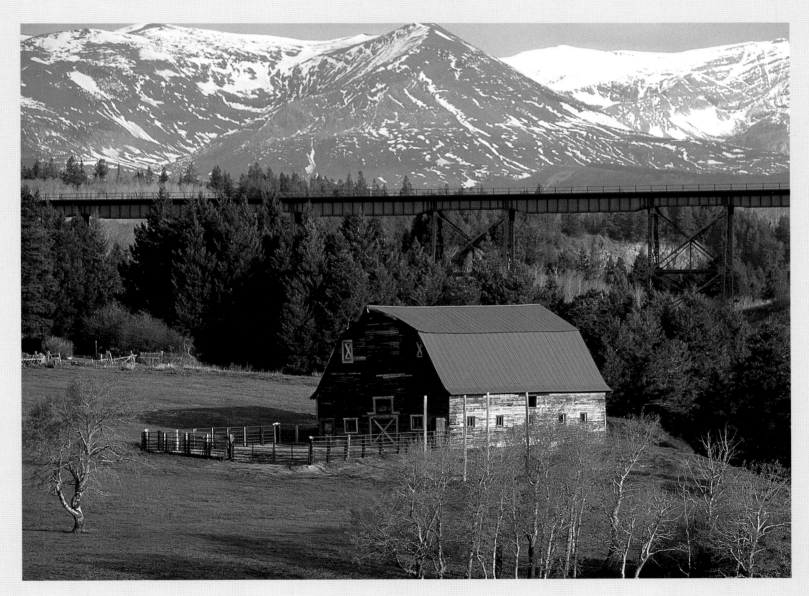

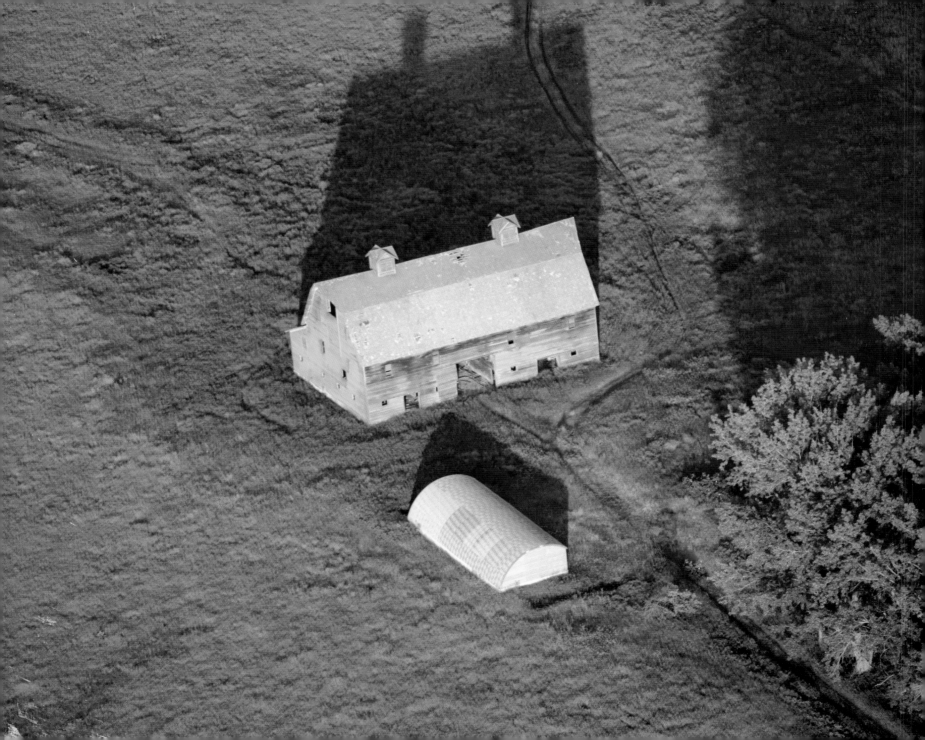

An affinity for barns

Just a couple of generations ago barns were common sights against Montana's big skies. In an era when the term "horsepower" actually meant the power of a horse, barns for teams of horses were a staple of farm life. Barns also stored hay to feed those working horses and wintering cattle.

Barns were built in a variety of shape, sizes, and styles. Immigrants often built barns showing a touch of old European heritage. Some barns were built with elaborate, handcrafted stonework while others were erected with sturdy wood planks and beams, held together by wooden pegs. Some were built with specific local conditions in mind, such as round barns that could withstand the blasts of Montana's prairie winds. Some were built with accompanying silos, an idea brought by settlers from Midwestern states who expected longer growing seasons. A lot of those silos never saw a drop of corn silage.

A hundred years ago barns helped define an era of hope and potential when settlers flocked into Montana with little more than the willingness to do backbreaking labor on raw land. Some didn't make the cut while others prospered. A large, well-built barn was a sign of prosperity and progress.

ABOVE: *One of the historic Fallon County barns*
FACING PAGE: *Aerial view of barn near Somers, Flathead Valley*

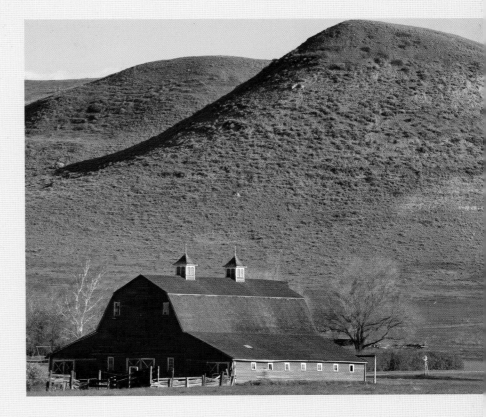

Perhaps that is why so many farmers and ranchers painted their barns red. A fine red barn standing proud and strong against a dusky blue sky must have been a comforting beacon to a weary farmer or rancher coming home from a long day in the fields and pastures.

I have a real affinity for barns. I grew up in a landscape dominated by farmers. I spent many hours building muscle (and character, I was told) by stacking bales in the haymow

and tending my livestock. In our youth, my cousins and I used to build elaborate tunnels through tall stacks of straw in Grandpa's barn. Later in the season when the bales had been depleted, we would use the space to play our own rough brand of barnyard basketball. On several occasions I have been accused of being "born in a barn."

Many Montana barns have vanished, succumbing to the ravages of time, the elements, and the economics of agriculture. Sadly, with each passing season the number of barns still standing in Montana diminishes and so do their stories. It costs a small fortune to keep up or restore these old barns and quite frankly, they just don't serve many useful purposes on modern farms and ranches. So each year the roofs tend to sag a little more, the walls creak under high winds, and foundations crumble. I'm so glad I had an opportunity to document many of these barns before they finally surrender to time or are torn down for their only tangible value: weathered wood that is prized for picture frames and trophy homes. I only wish I could have started earlier. It's not only the structures that are disappearing but also a simpler way of life.

A few Montana barns still stand tall today, and I spent many days traveling Montana's roadways searching out barns for this book. I'd like to thank all of those who so graciously let me photograph their barns and ask them a mile's worth of questions. I really appreciated their hospitality and the friendliness that makes Montana so unique. ♦

Chuck Haney

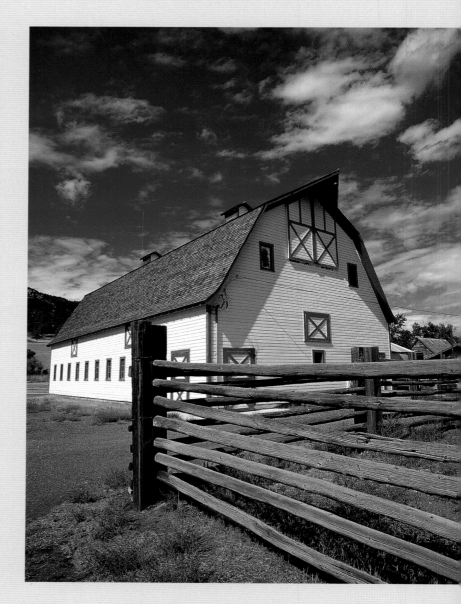

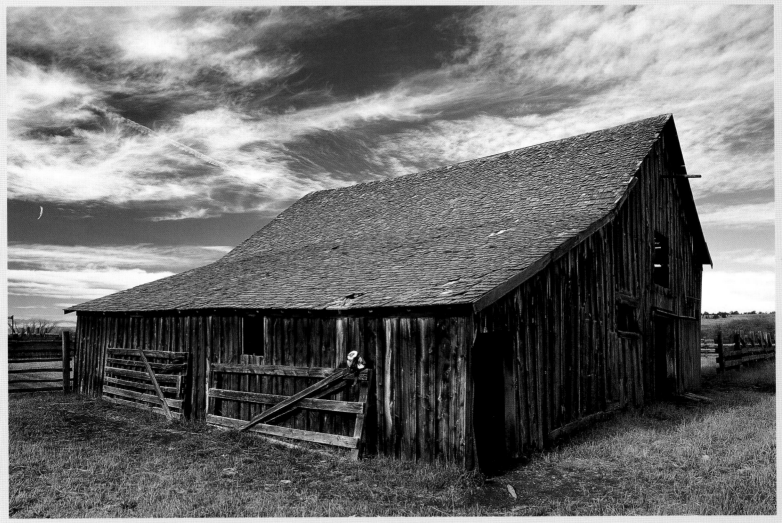

ABOVE: *A well-worn cattle barn on the Lee Ranch in the Big Snowy Range*
FACING PAGE: *Worth Ranch barn, Wolf Creek*

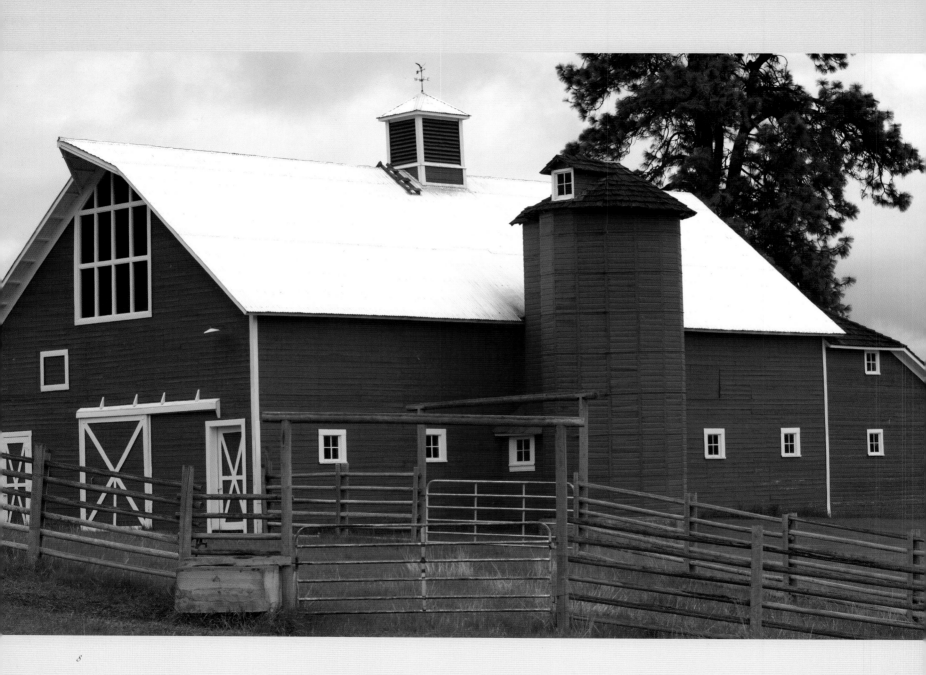

Bigfork Barn

*T*his attractive barn sits on a bench of land near Flathead Lake with an outstanding view of the Swan Mountains. It was built in 1900 by the George Paul family. Originally from St. Louis, they came to the Flathead Valley in 1894 via the Colorado gold fields.

The Kootenai Indians probably used this site as a camp because they left ax marks in a big ponderosa pine bordering the barn. They extracted cambium from the tree and boiled the sap into thin sweet syrup.

The barn was built with hand-hewn ponderosa pine and framed together with sturdy 4 x 4 studs. A silo was constructed to store corn silage for beef and dairy cattle, but the growing season proved too short for growing corn so the silo was never used. There is evidence of similar unfulfilled optimism in other Flathead Valley farms as well.

The barn originally housed teams of horses. Later it was used as a dairy. A large haymow used a pulley and track system to lift and stack the loose hay to feed livestock during the winter months.

The Pauls raised six sons at the farm and the barn stayed in the family until the farm was sold in 1952.

The barn has been owned by the George Darrow family since 1968 and is in remarkable condition for being more

ABOVE: *A window decoration in the Bigfork barn.*
FACING PAGE: *The Bigfork barn*

than 100 years old. The flooring and roof have been replaced, and the barn has been painted twice since Darrow took over. The original 1894 homestead cabin has been beautifully kept up and George Darrow now uses it as an office. ♦

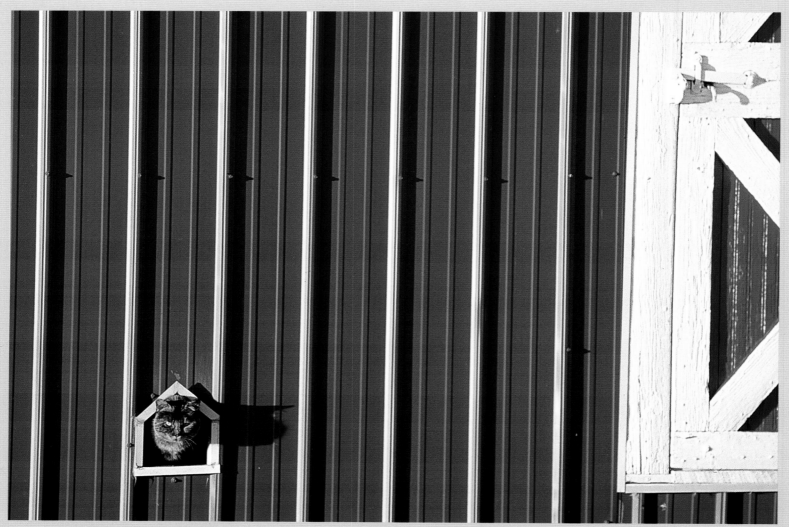

ABOVE: *Barn cat in its own barn door*

FACING PAGE: *Nice red barn on a winter day in the Flathead Valley*

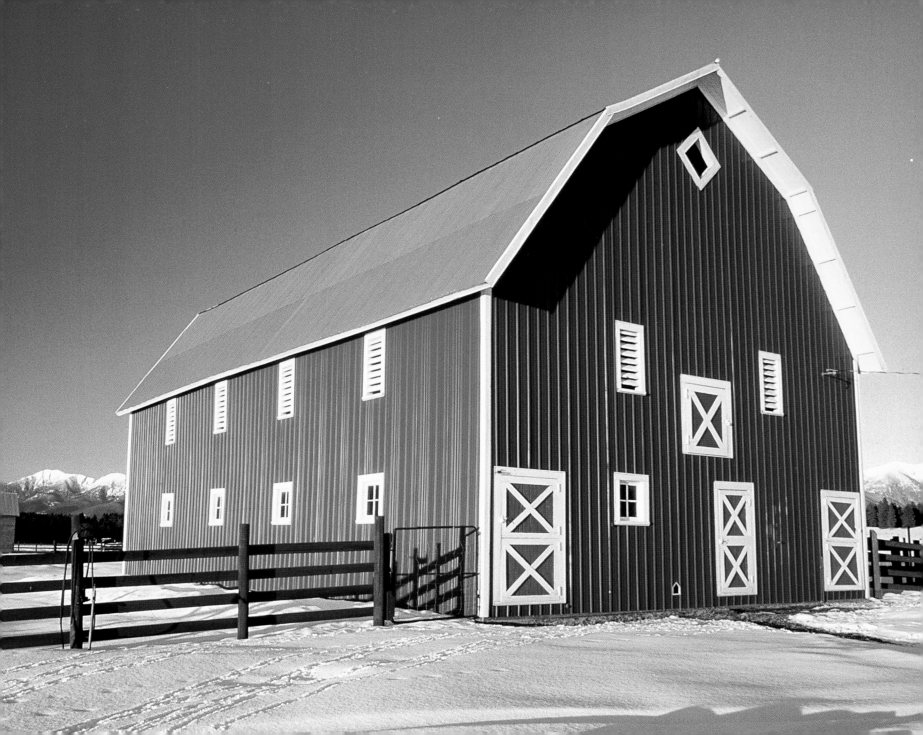

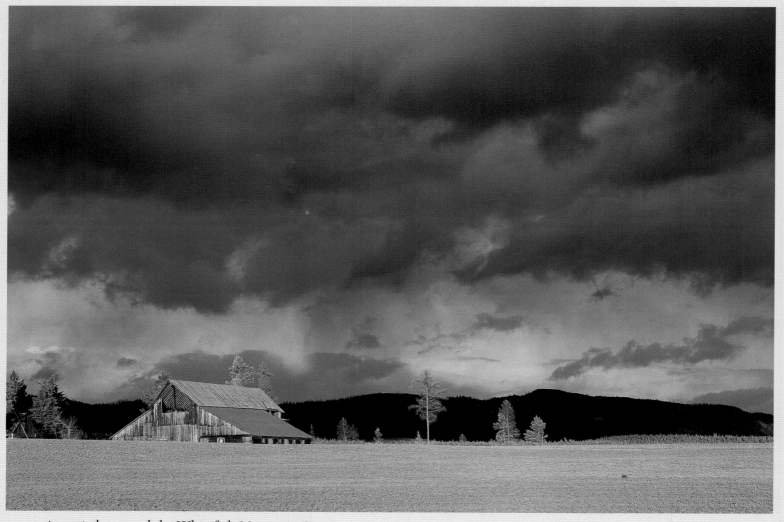

ABOVE: *A rustic barn and the Whitefish Mountain Range*
FACING PAGE: *A barn built in 1914 near Belgrade and the Bridger Mountains*

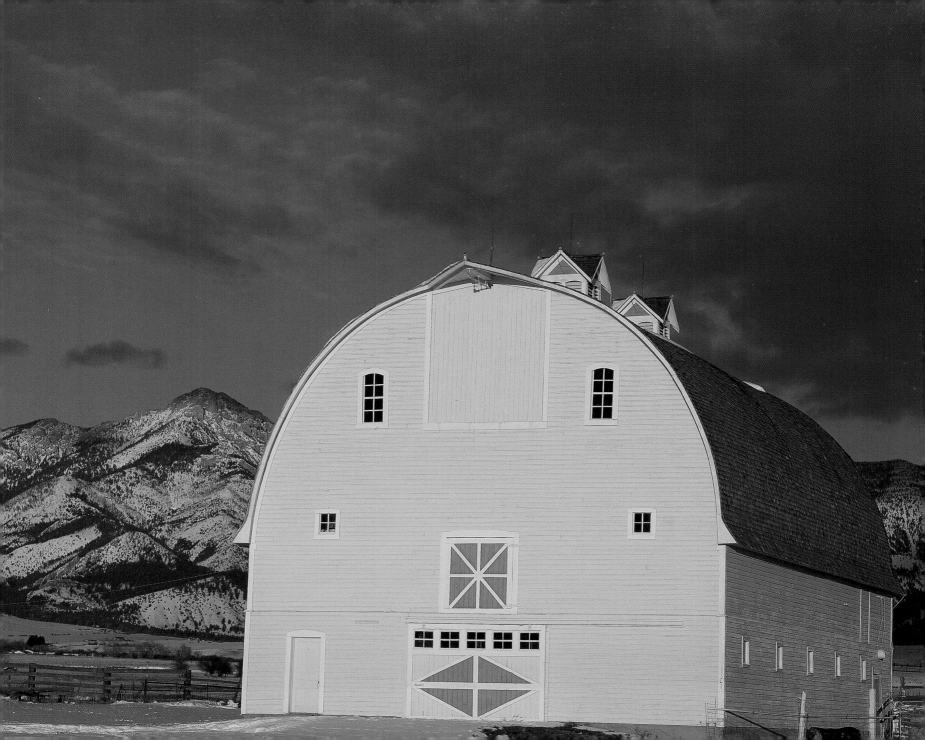

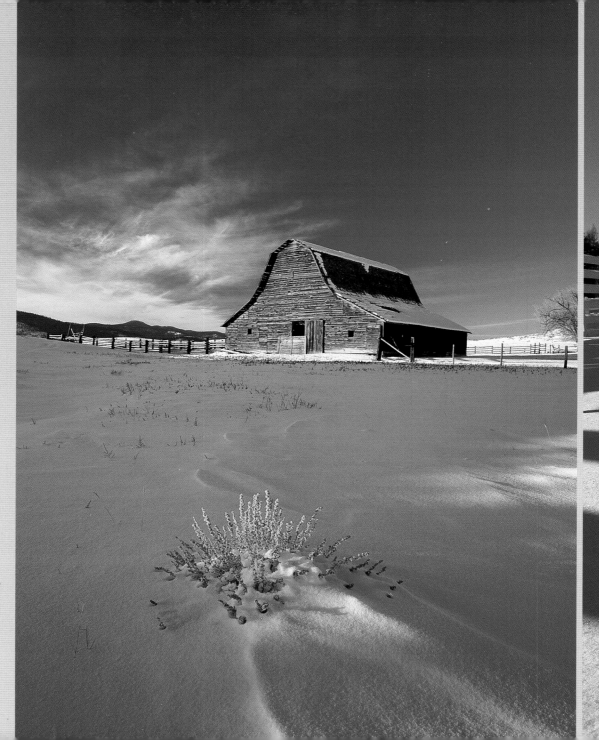

RIGHT: *Old cattle barn near Hot Springs*

FACING PAGE: *The historic Hodgson Dairy Barn (circa 1907), Flathead Valley*

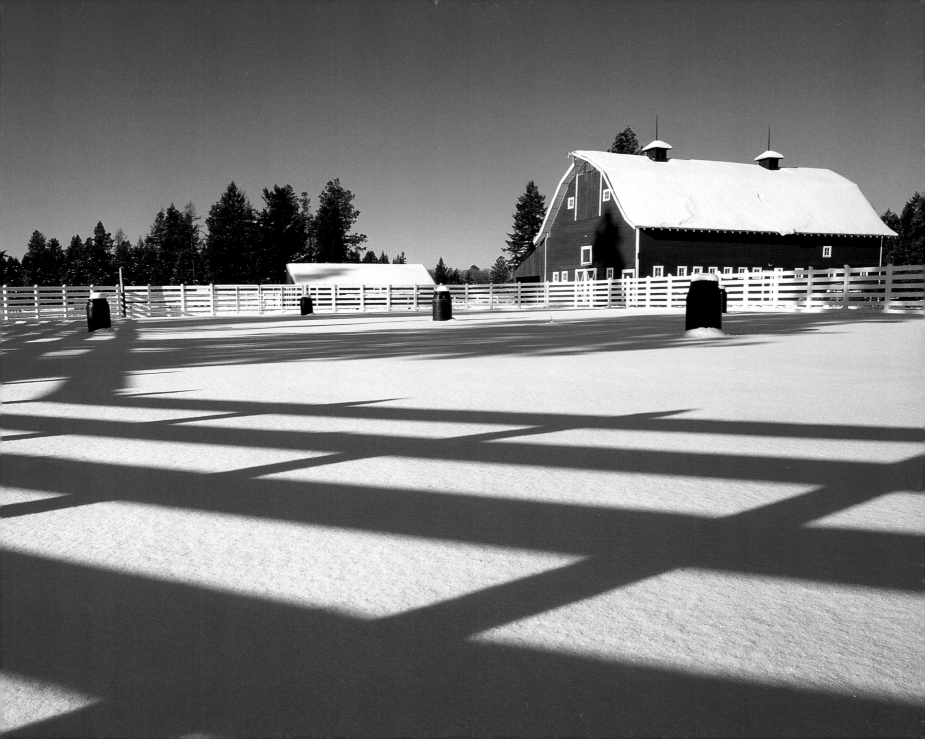

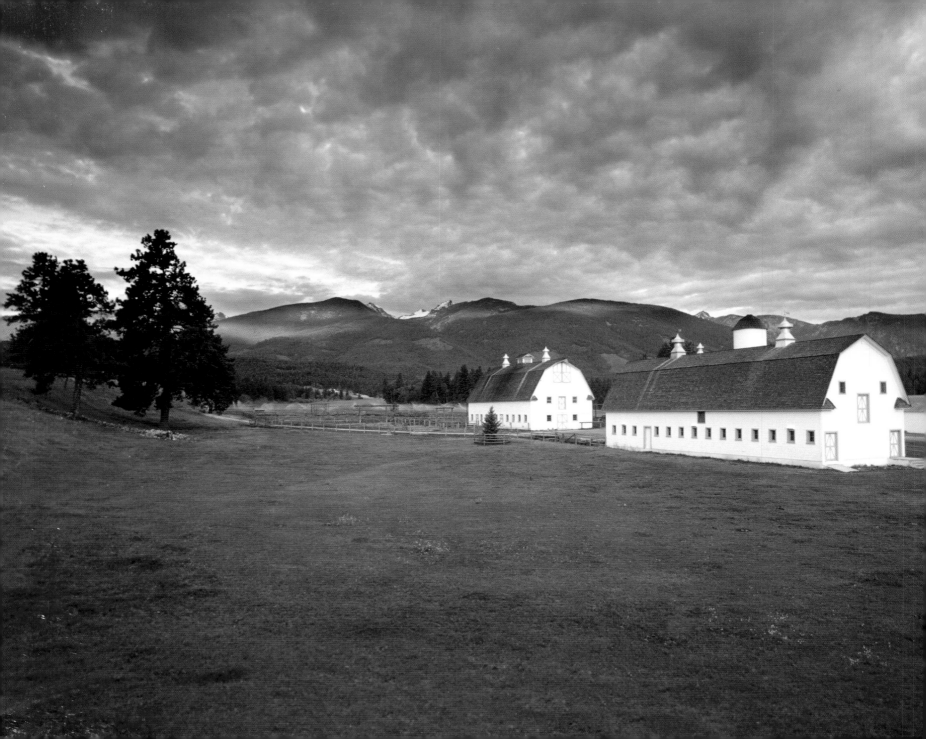

Chief Joseph Ranch

*T*hree beautifully restored dairy barns are nestled between the dramatic peaks of the Bitterroot Mountains to the west and the Sapphire Mountains to the east. In 1805 and 1806 the Lewis and Clark Expedition probably trekked right through the very spot the where these barns now reside.

In the early 1900s the Bitterroot Valley was known for its numerous apple orchards. Around 1914 a wealthy businessman from Ohio named William Ford started constructing the ranch buildings that still stand today. Ford was looking for a comfortable but working retreat. He spared no expense in building the main lodge and the large barns that housed one of the nation's leading Holstein dairy herds. Ford imported some of the best breeding bulls. It was reported that he paid more than $100,000 for his prize bull named Imperial Prince.

When it was the Ford and Hollister Ranch, the barn was a model dairy, perhaps one of the finest operations in the United States. The barns and equipment, such as conveyor belts to remove manure, and separate housing for the bulls were state of the art.

There are three barns ranging in size from 3,000 to 4,500 square feet. There are 35 to 40 windows in each barn. The property is now owned by the Shupp family and serves as a guest ranch. ♦

ABOVE: *A humorous weather vane*
FACING PAGE: *The Chief Joseph Ranch barns near Darby*

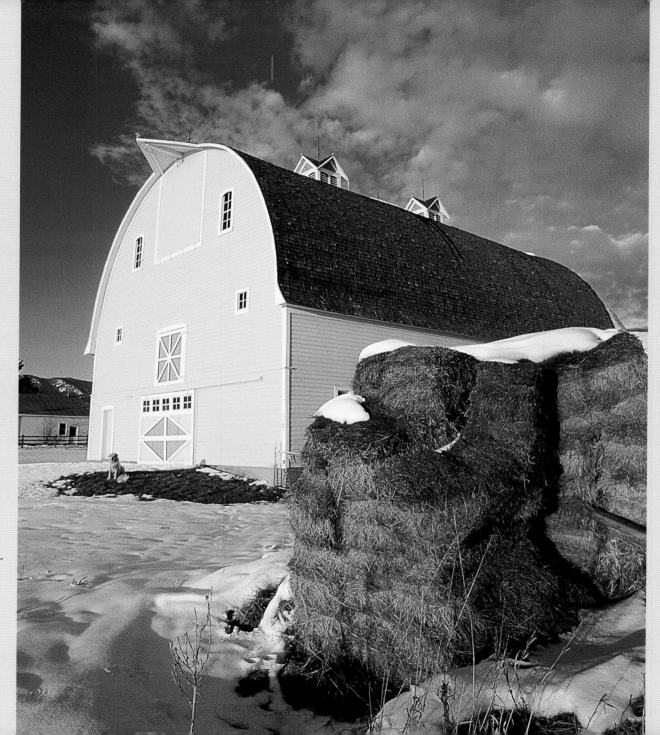

RIGHT: *1914 barn near Belgrade*

FACING PAGE: *"The Barn" at St. Ignatius*

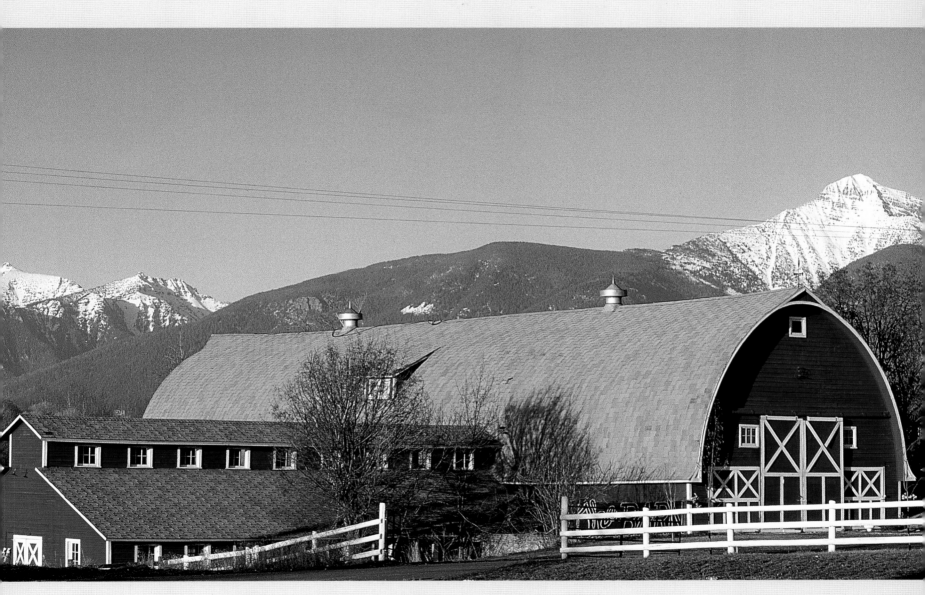

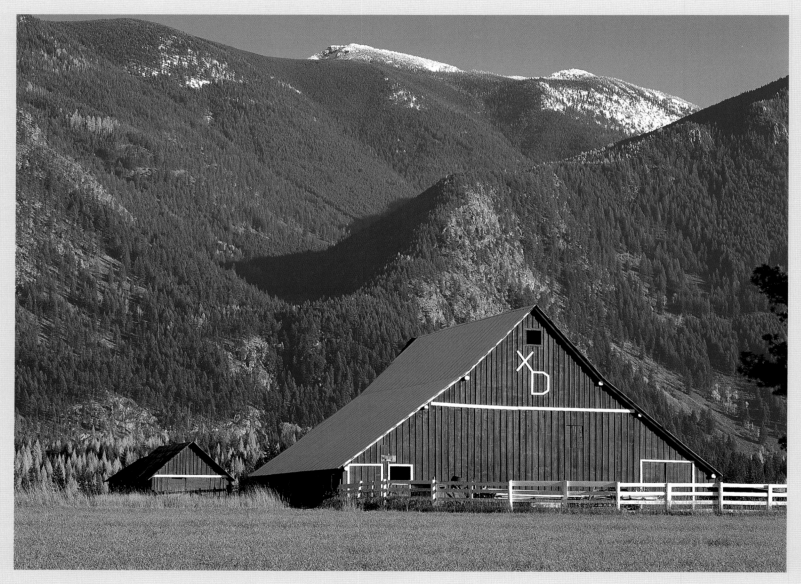

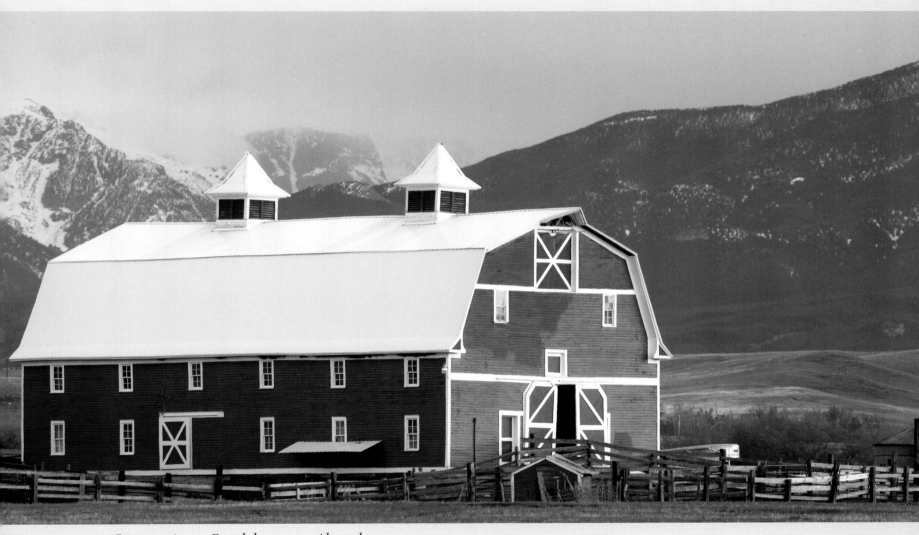

ABOVE: : *Lantana Angus Ranch barn near Absarokee*
FACING PAGE: *A-frame barn built in 1911, Winslow Ranch, Troy*

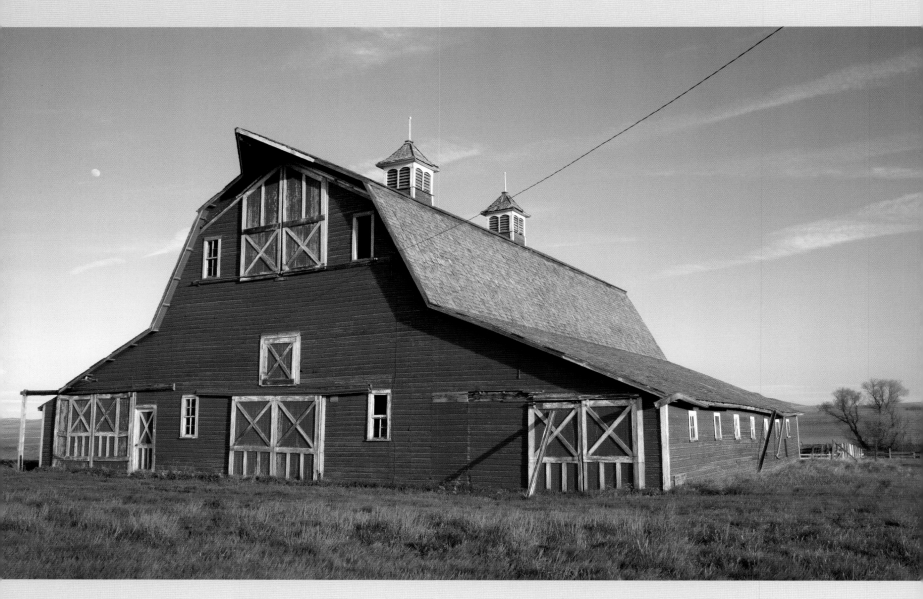

Fallon County Barns

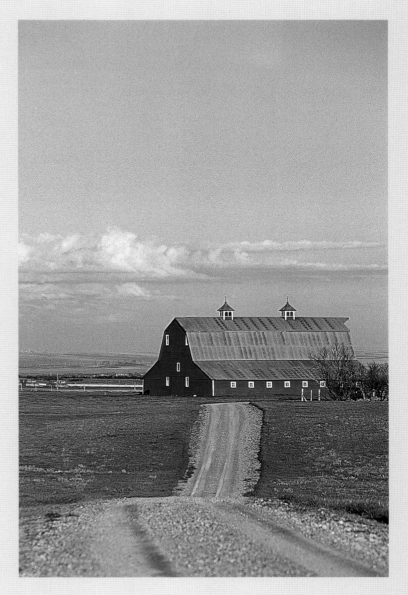

Out among the wide-open vistas and badlands along Montana Highway 7 between Baker and Ekalaka are several large red barns with similar styles. Besides being the usual homes for workhorses and the storing of hay, the barns were used as night stopovers for freighters pulling wagons of grain and supplies between Baker and Ekalaka.

Around 1910 many homesteaders came to this part of eastern Montana to stake a claim. Ed Blaser was one such man. He used his savings to ship out lumber, horses, used machinery and a few chickens in an immigrant rail car.

In 1918, Willard Wills built a barn for Blaser just south of Wills' barn, on land purchased from the Northern Pacific Railroad. It would be seven more years of surviving little rain, poor crops, and legions of grasshoppers before Ed and Bertha Blaser could move from their little claim shack into a real house.

Jerry and Kathy Sikorski now own the barn and are determined to keep it up. The barn has been used to house horses and pigs, and it helps during the calving season. ♦

RIGHT: *One of the historic Fallon County barns*
FACING PAGE: *A Fallon County barn*

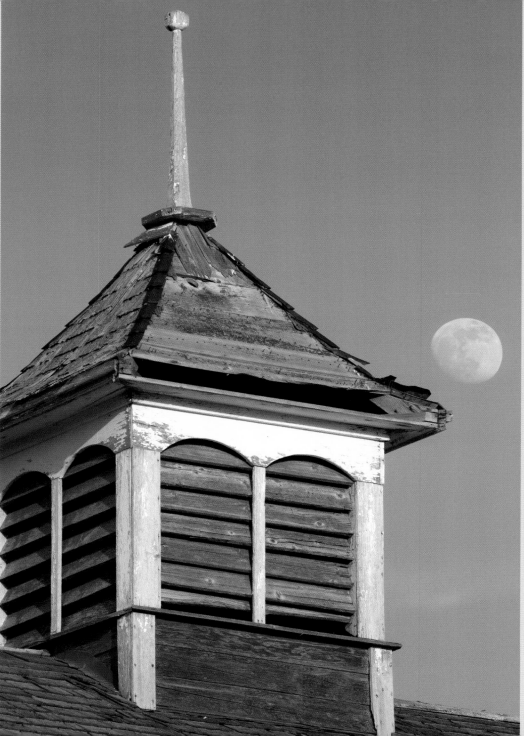

ABOVE: *Hinges on a weathered red barn, Willow Creek*

RIGHT: *Moon and Fallon County barn cupola*

FACING PAGE: *A tall barn near Reed Point*

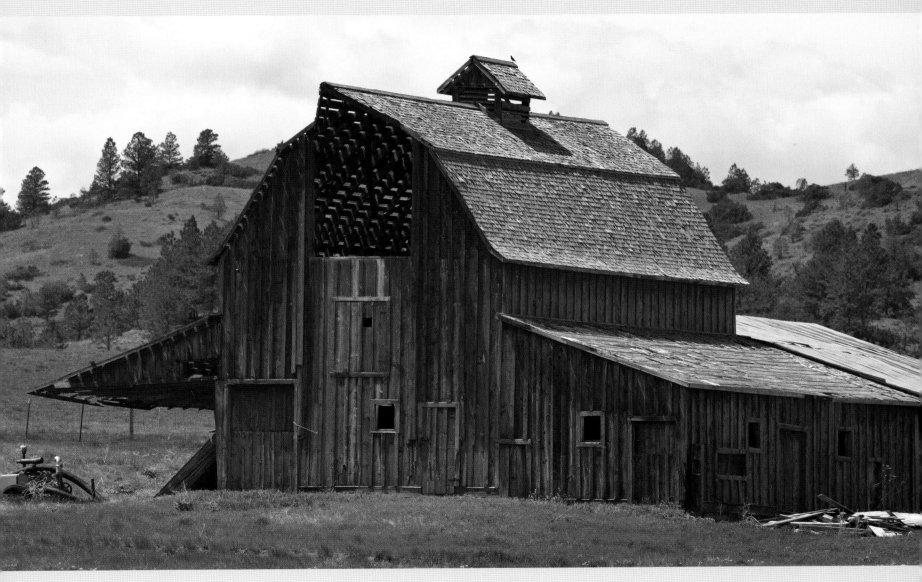

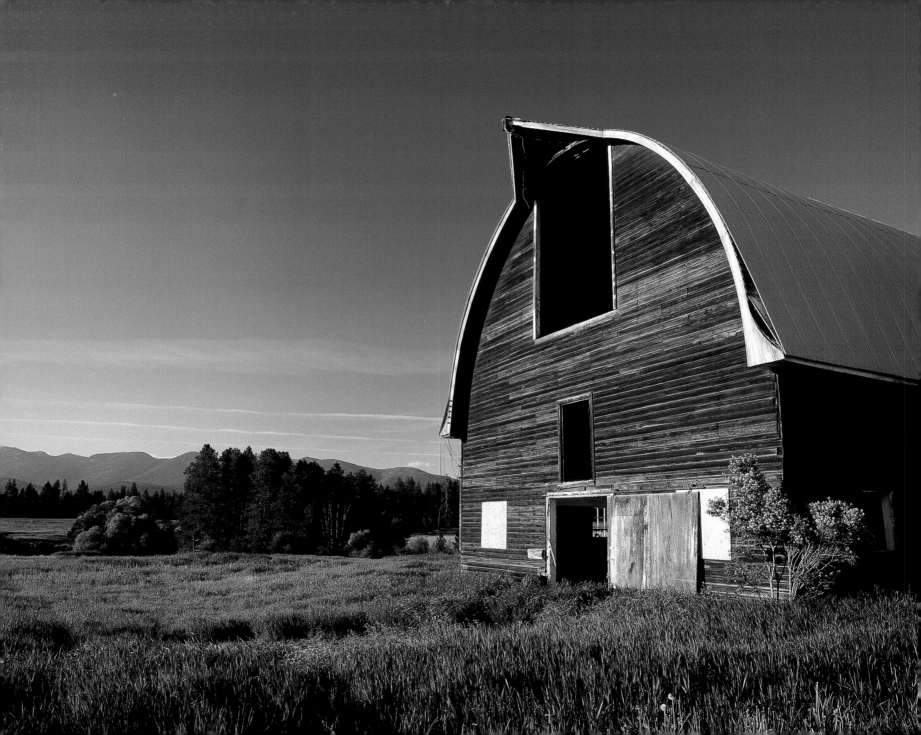

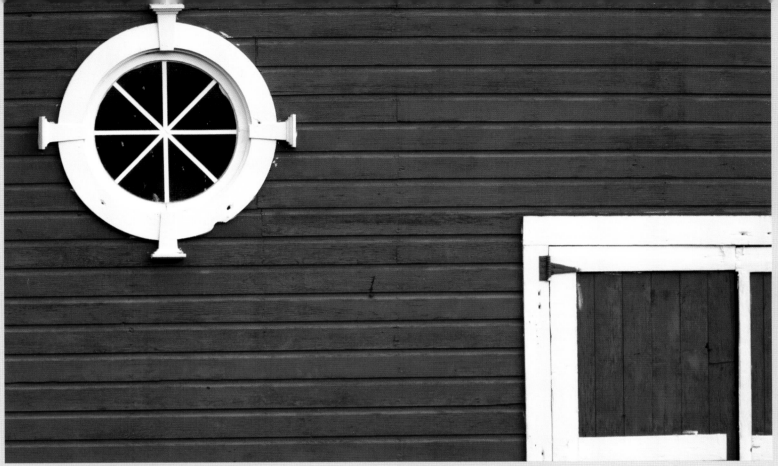

ABOVE: *An uncommon round window in a Big Snowies barn*

LEFT: *"Mouser," the barn cat, at its home in Marion*

FACING PAGE: *An old dairy barn along the Whitefish River*

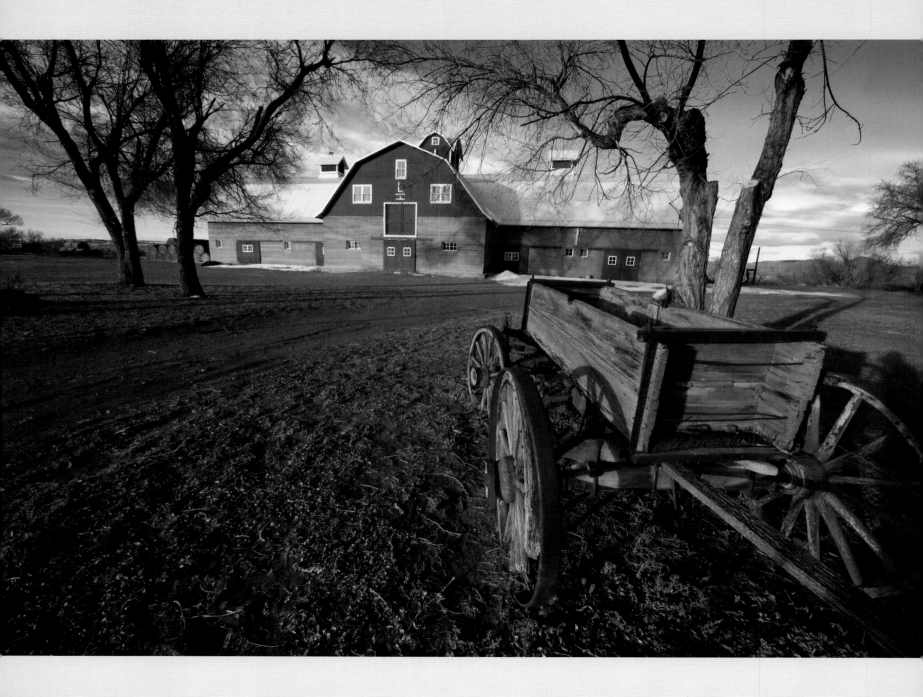

FROMBERG
Gebo Barn

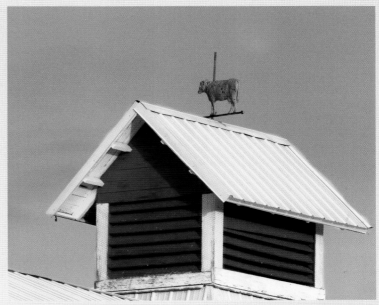

This impressive barn sits near the Clarks Fork of the Yellowstone River and is considered a local landmark. It was built around 1909 by Samuel Gebo, who made his fortune developing local coalmines.

The colorful barn was constructed with 20-foot-high concrete walls and a gambrel roof. The barn was originally used by Gebo to shelter his purebred Belgian horses, other livestock, and some equipment. The barn represents the prosperity of the Clarks Fork area from coal mining and dry land farming between 1909 and 1913.

Shortly after a party of 300 people celebrated the barn's completion, Gebo was indicted on federal fraud charges. After pleading guilty, he left for Guatemala and auctioned off the Fromberg farm. The Hill family has owned the land and barn for the past 60 years.

The barn is still in nice condition and features three cupolas with weather vanes of a beef, a sheep, and a horse. The barn was recently placed on the National Register of Historic Places. ♦

TOP RIGHT: *Gebo Barn cupola*
RIGHT & FACING PAGE: *The Gebo Barn*

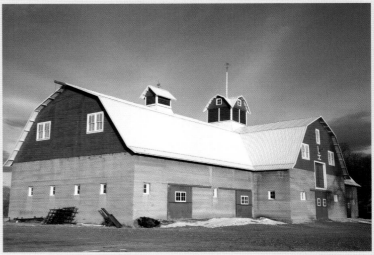

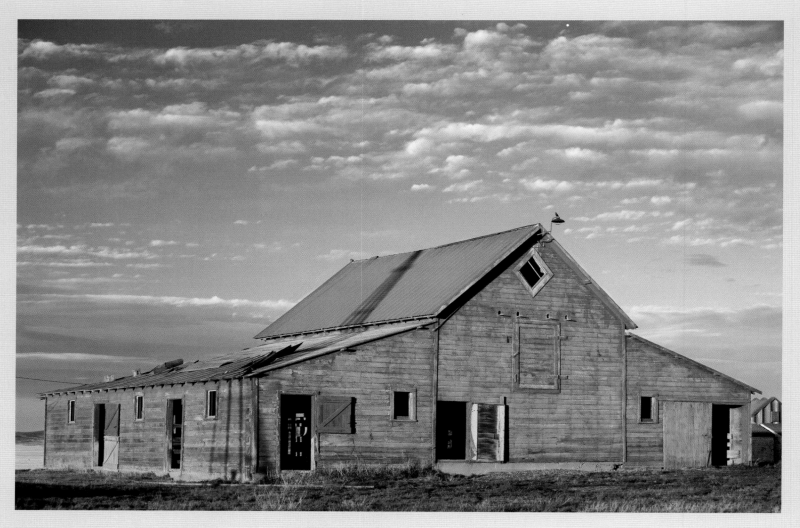

ABOVE: *The large barn near Molt*

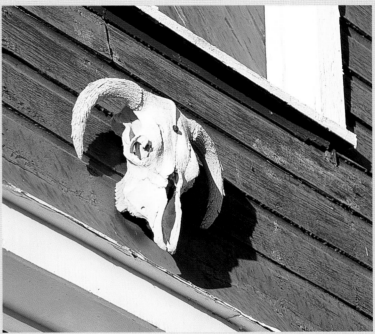

ABOVE: *Skull decorating the side of the Kleffner barn*
LEFT: *Detail of the Molt barn*

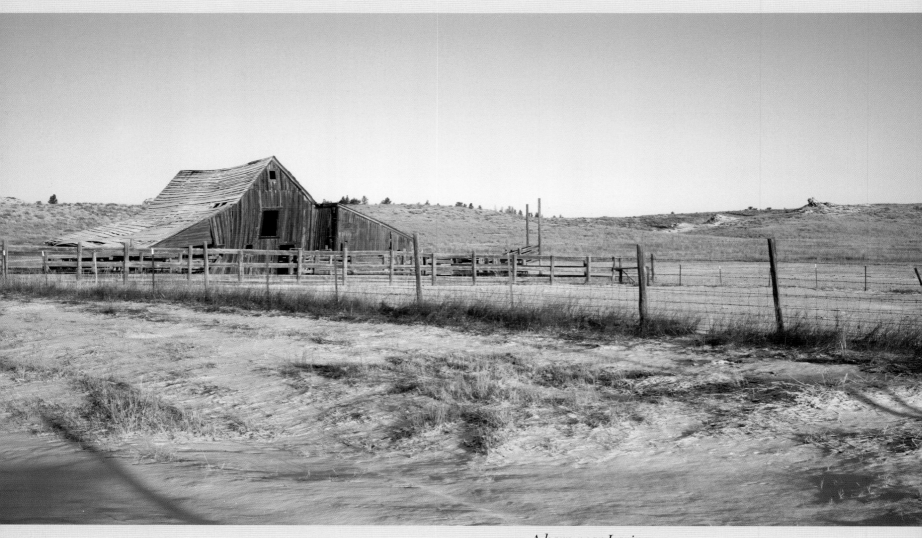

ABOVE: *A barn near Lavina*

FACING PAGE: *A Fromberg barn under the rimrocks*

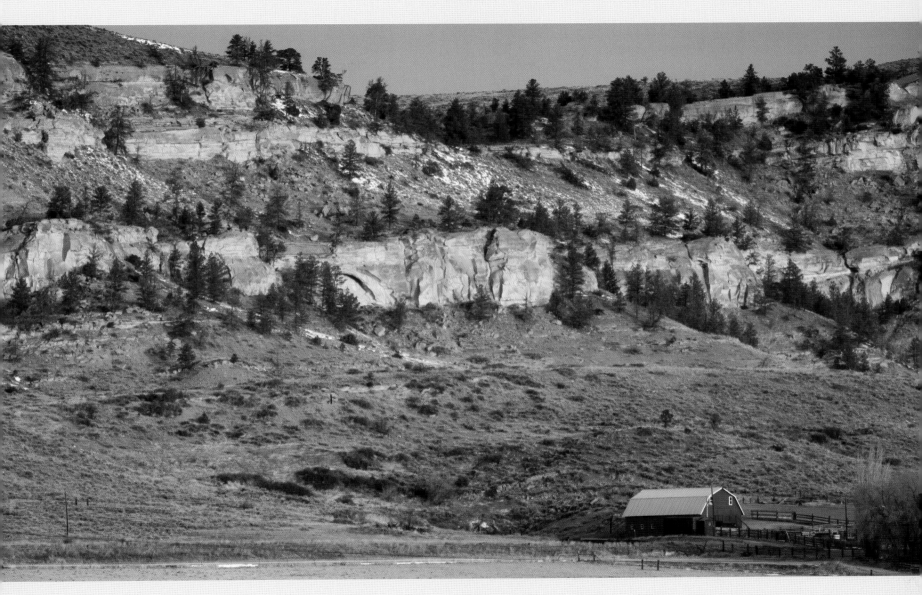

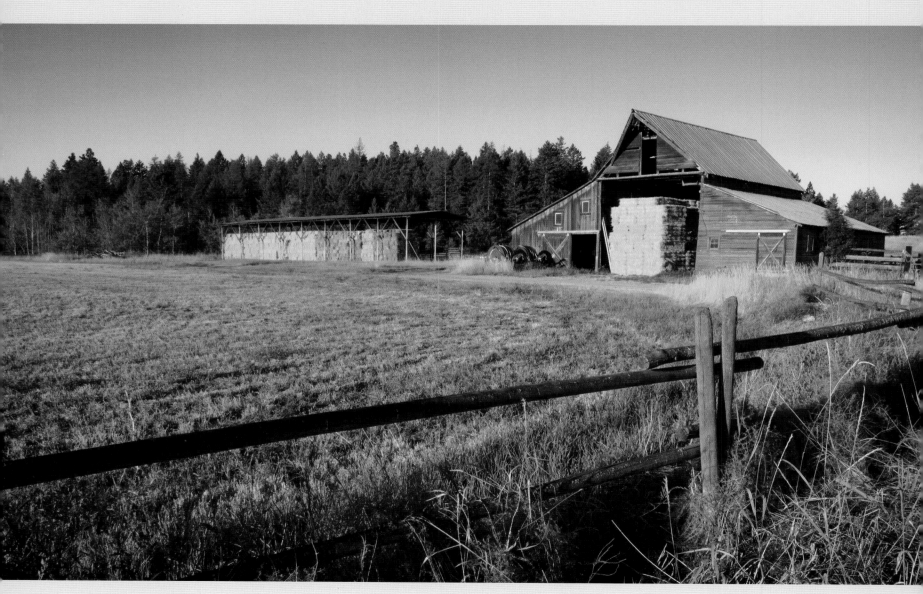

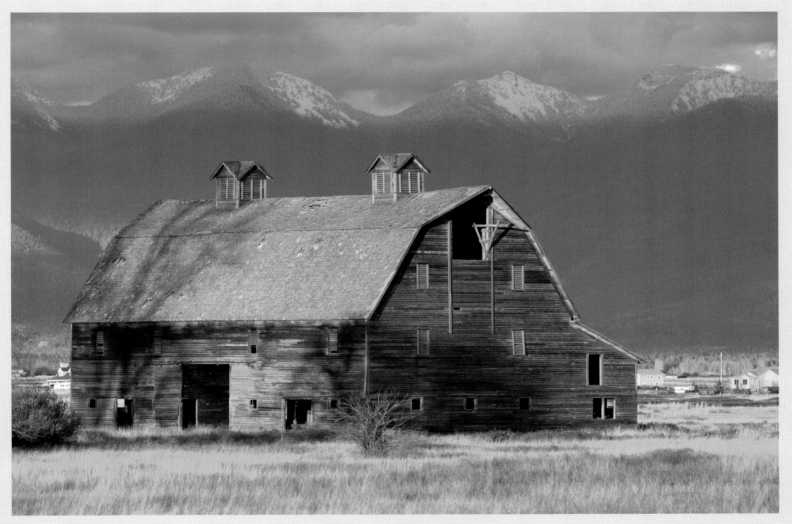

ABOVE: *A barn at Somers*

FACING PAGE: *Hay in a Flathead barn*

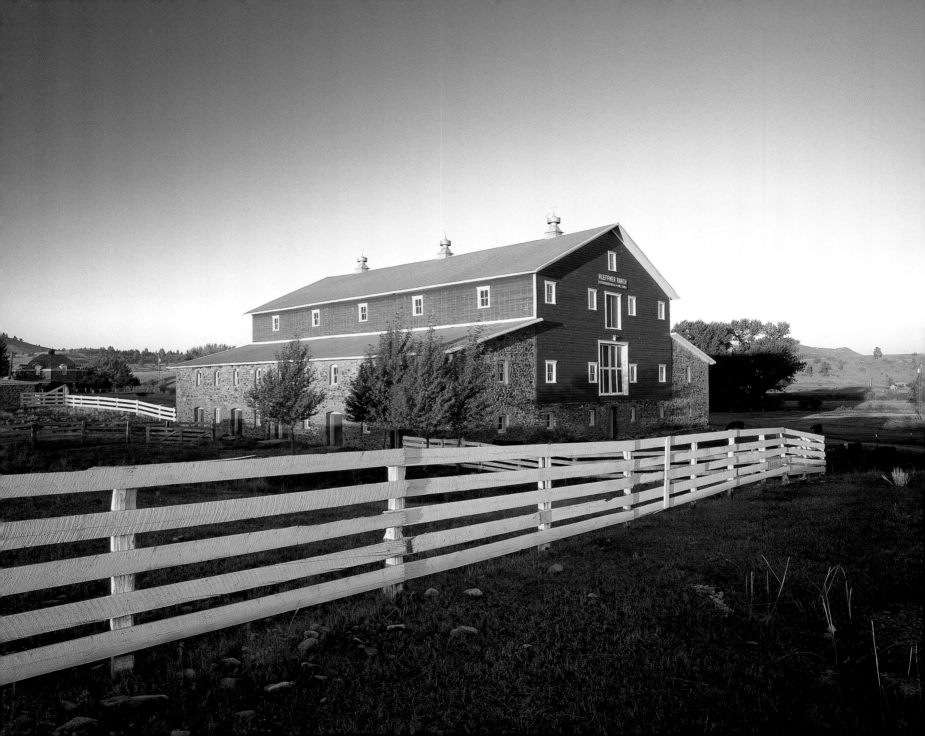

Kleffner Barn

In the late 1880s William C. Child built the Whiteface Ranch in the Helena Valley. The severe winter of 1886-1887, when most of Montana's cattle died on the open range, prompted Child to build a barn large enough to hold 500 head of his prized purebred Hereford cattle during any storm that could rage across Montana. The barn is believed to be the largest old barn in the western United States. It is accompanied by one of the few octagonal homes west of the Mississippi River.

The three-story barn is 54 feet high and contains an enormous 27,000 square feet of floor space. Skilled Italian stonemasons used river rock to build stone foundations measuring 100 by 100 feet.

The lower level of the barn was designed for the 500 head of cattle while the main floor was used for wagons and equipment. The third floor was the hayloft where 300 tons of hay could be stored and then pitched down to the cattle. The barn has more than 70 windows.

ABOVE & FACING PAGE:
The 27,000-square-foot Kleffner Barn, built in 1888

Childs lost the farm after the silver panic of 1893. He died that same year and the ranch passed through many owners during the next 60 years. It became neglected and run down.

Paul Kleffner and his wife Thelma bought the place in 1943 and spent the next half-century beautifully restoring the historic barn. Now the well-preserved barn is a gathering place for weddings and reunions, and it has become a tourist attraction complete with tours. It is on the National Register of Historic Buildings. ♦

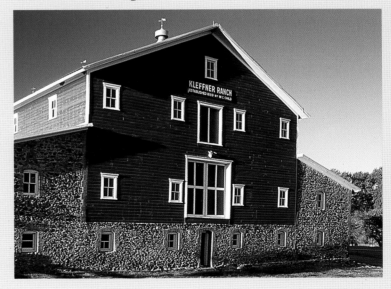

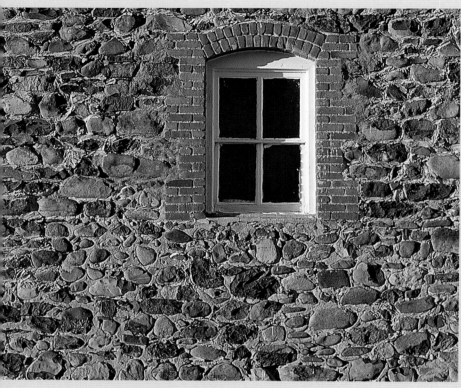

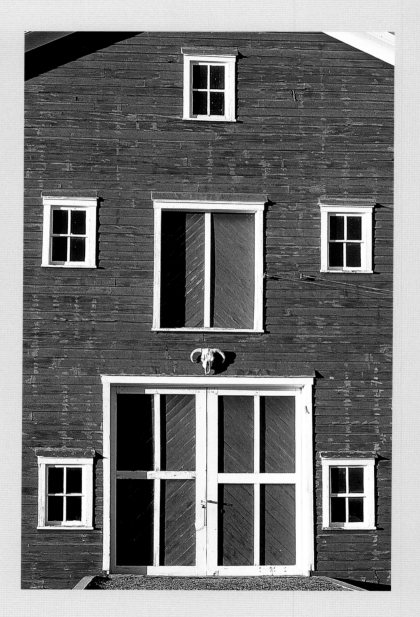

ABOVE & RIGHT: *Details of
the Kleffner Barn*
FACING PAGE: *A barn near Park City*

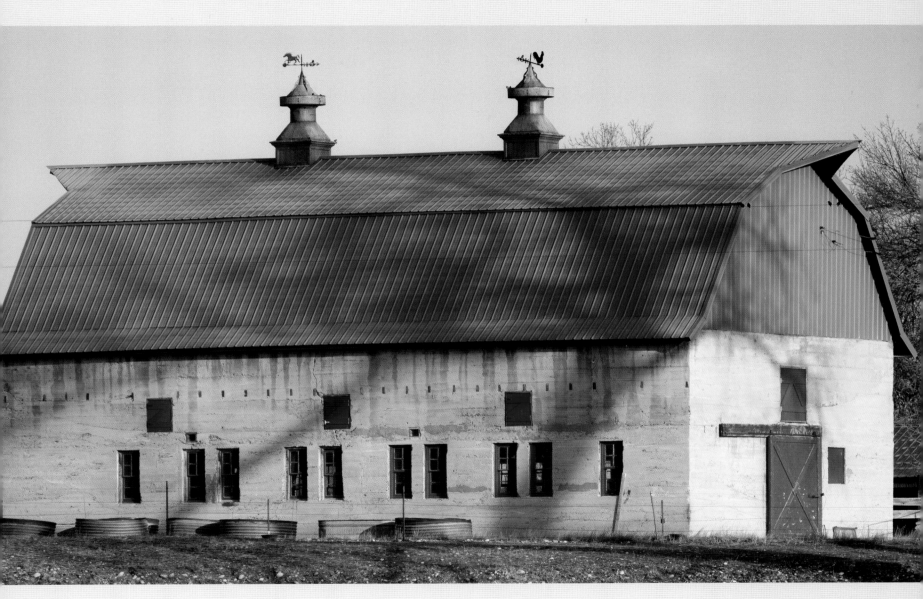

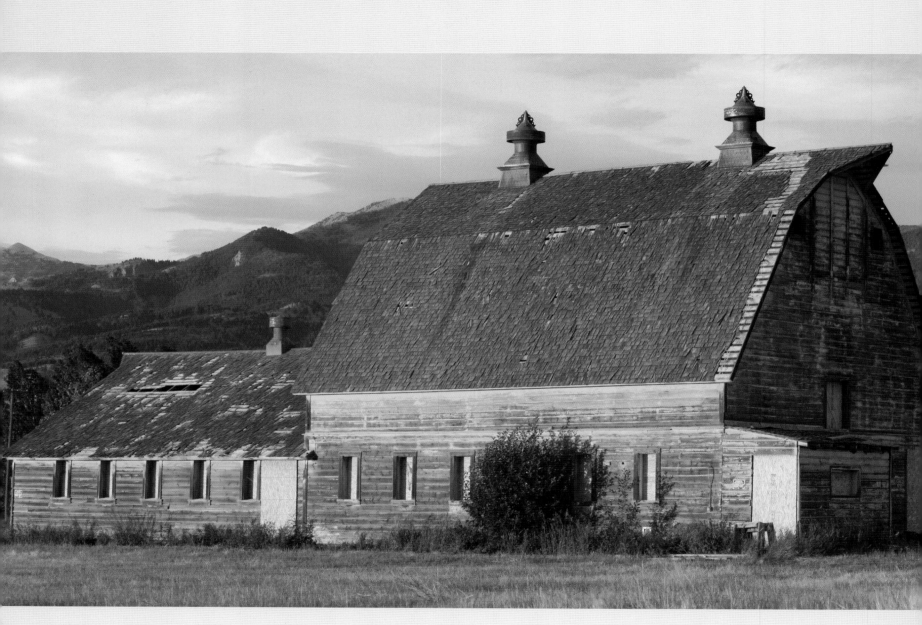

ABOVE: *A cattle barn near Lincoln*

FACING PAGE: *A grand old barn near Bozeman*

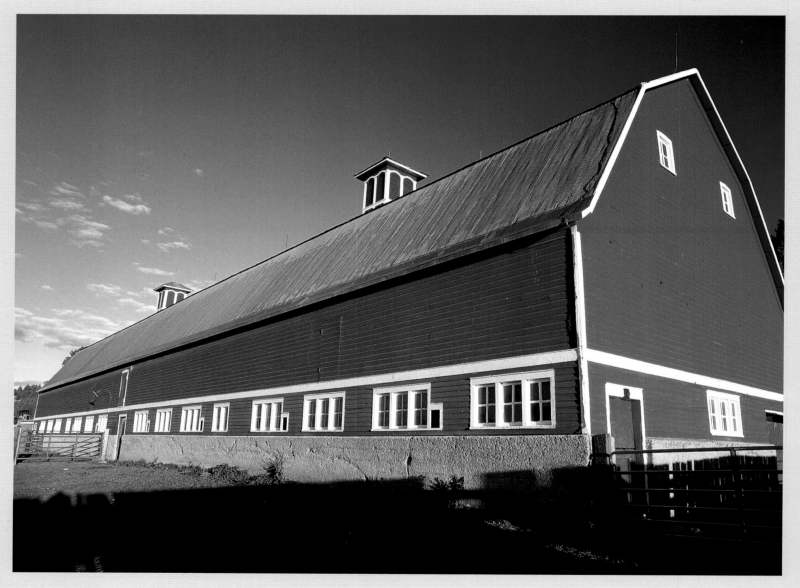

Lewistown Dairy / Comes Ranch

This prominent looking structure with its lengthy walls, classic bright red and white paint, and high gambrel roof sits near Spring Creek, just down the road from Lewistown. Master craftsman John Plank constructed the barn in 1913. Plank also built many other barns in the area.

This barn housed the Lewistown Dairy until it closed in 1948. In its dairying heyday, the barn was outfitted with 97 milking stanchions and stocked with more than 200 tons of hay.

The barn still has a useful life. Its current owners, Sonny and Mary Lee Comes, run cattle and use the barn for spring calving and stabling horses.

The Comes family has wonderfully preserved the barn. Over time they have repaired every one of the 368 windowpanes, installed a new roof, and straightened and realigned the interior framing, among many other repairs. Every seven years or so they coat the entire outside with 50 gallons of paint: 40 red and 10 white. ♦

RIGHT & FACING PAGE: *The well-kept Lewistown Dairy Barn, built in 1913*

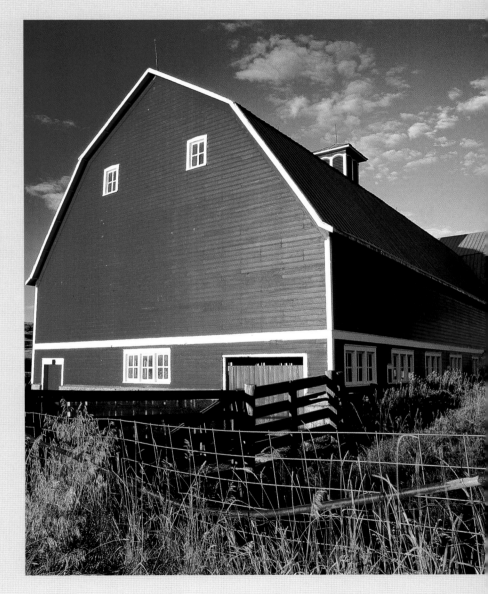

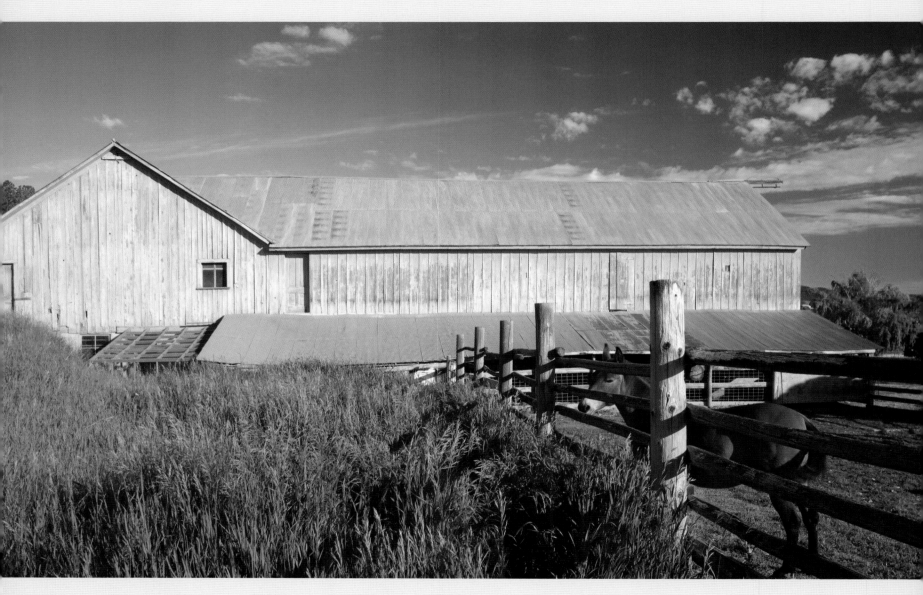

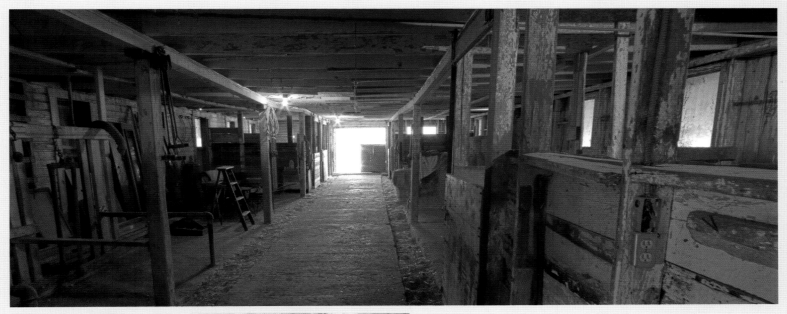

ABOVE & LEFT: *Interior of the Powell dairy barn*
FACING PAGE: *The Powell dairy barn near Lewistown*

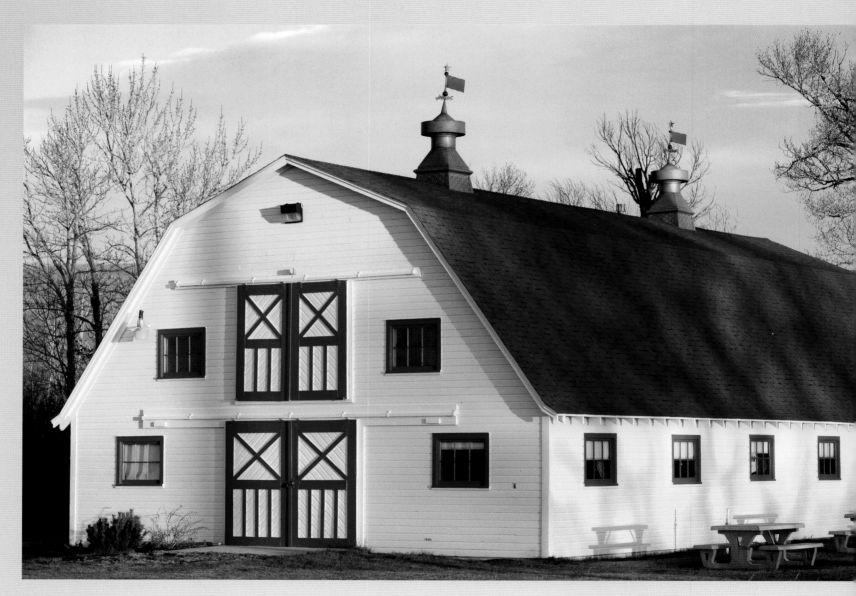

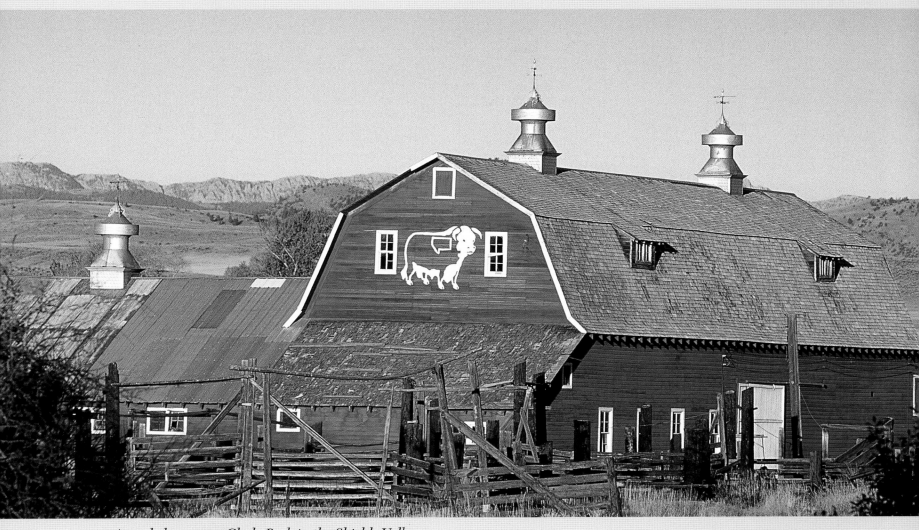

ABOVE: : *A cattle barn near Clyde Park in the Shields Valley*
FACING PAGE: *The main barn on the historic Bair Ranch, Martinsdale*

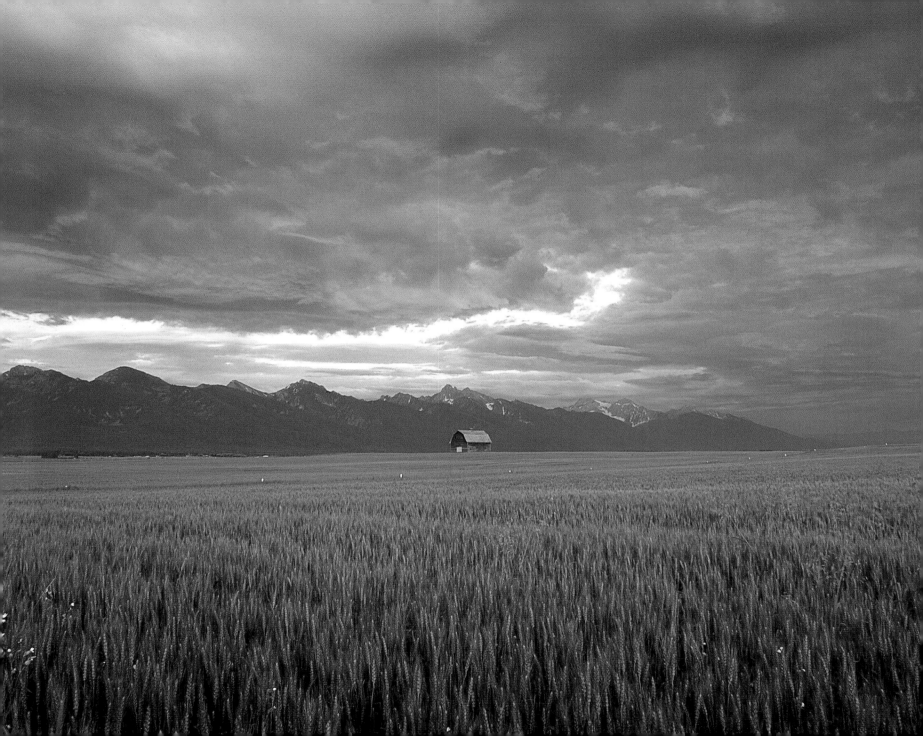

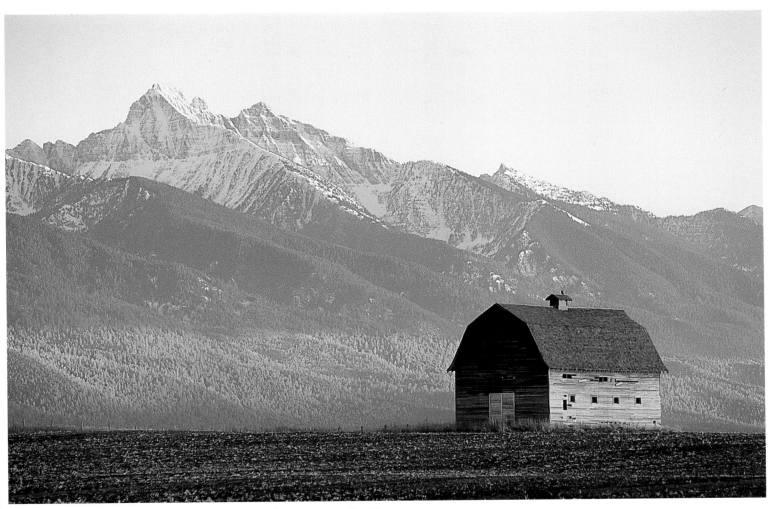

ABOVE & FACING PAGE: *The often-photographed Mission Valley Barn near Pablo, with the Mission Mountains in the background*

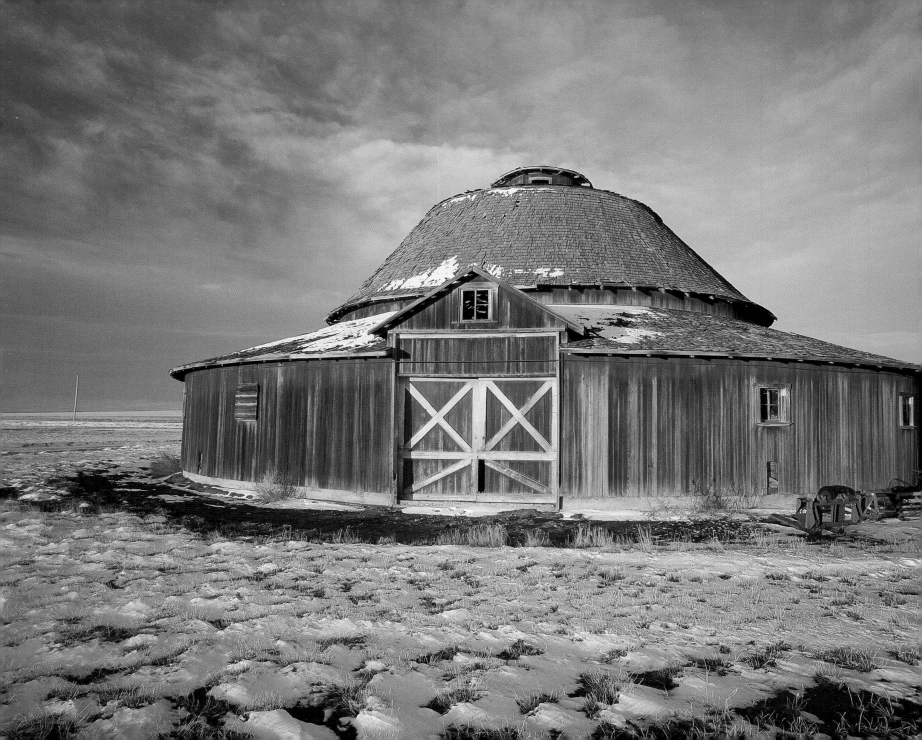

Rossmiller Round Barn

M. J. MacDonald homesteaded this land in 1910. This unique barn was built in 1917. Two rail cars of lumber were shipped from Eureka to Brady where the lumber was then hauled to the site with horses and wagons. The reasoning for the round shape was to better withstand the sometimes-ferocious winds on the open prairie.

The barn measures 262 feet in circumference. Sturdy 2 x 6 studs were used for framing the outside perimeter and the roof was covered with wooden shingles. Cows resided on one side of the barn while weaning calves were on the other. Twenty horse stalls were placed in the middle. Hay was stored on the second level on the outside circle.

The MacDonald family sold the farm to Elmer Rossmiller in 1944 and it has been in the Rossmiller family ever since. It has been the source of attention from many curious travelers along the historic Bootlegger Trail. Automobiles have often stopped alongside the gravel road to take photos.

The Rossmillers have never used the barn for anything important. They resisted tearing down the structure after neighbors voiced their concerns, but the barn has seen better days. A hailstorm in 1993 did much damage to the roof and the barn is caving in. One of the few round barns in Montana is soon to be only a memory. ♦

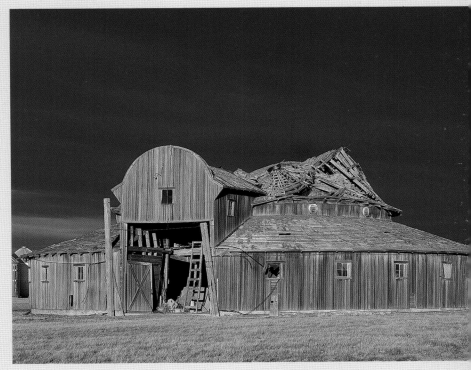

ABOVE & FACING PAGE: *The Rossmiller round barn near Brady*

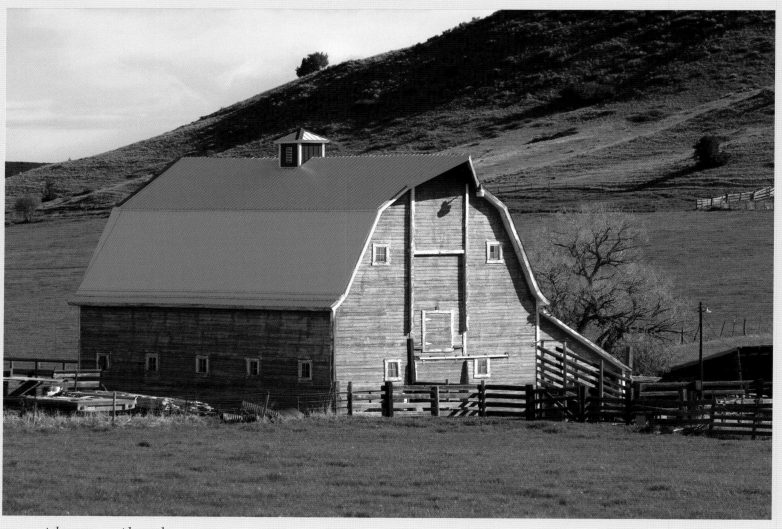

ABOVE: *A barn near Absarokee*

FACING PAGE: *A barn near Hanover, north of Lewistown*

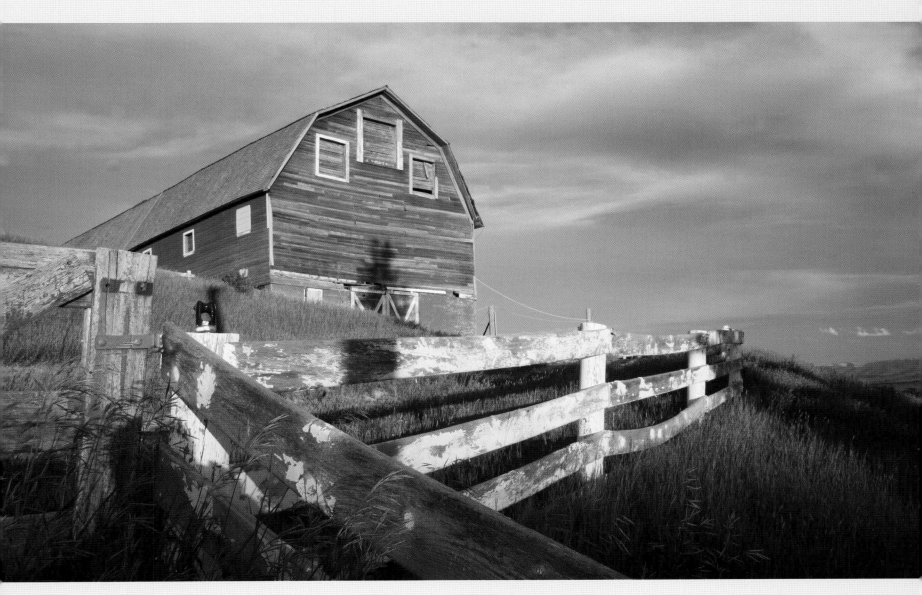

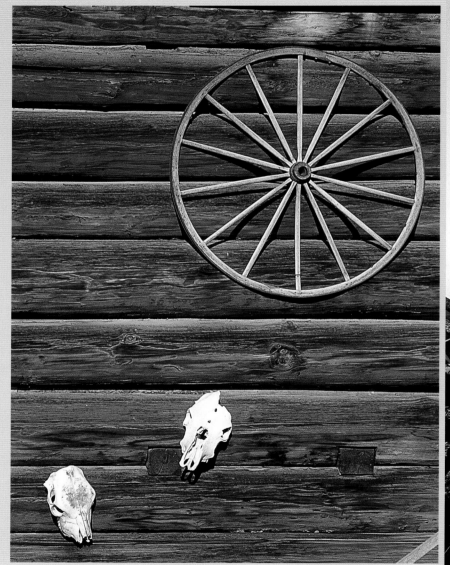

RIGHT: : *Decorations on the Hargrave Ranch barn near Marion*
FACING PAGE: *A nice old barn for cattle and hay in the Big Hole Valley*

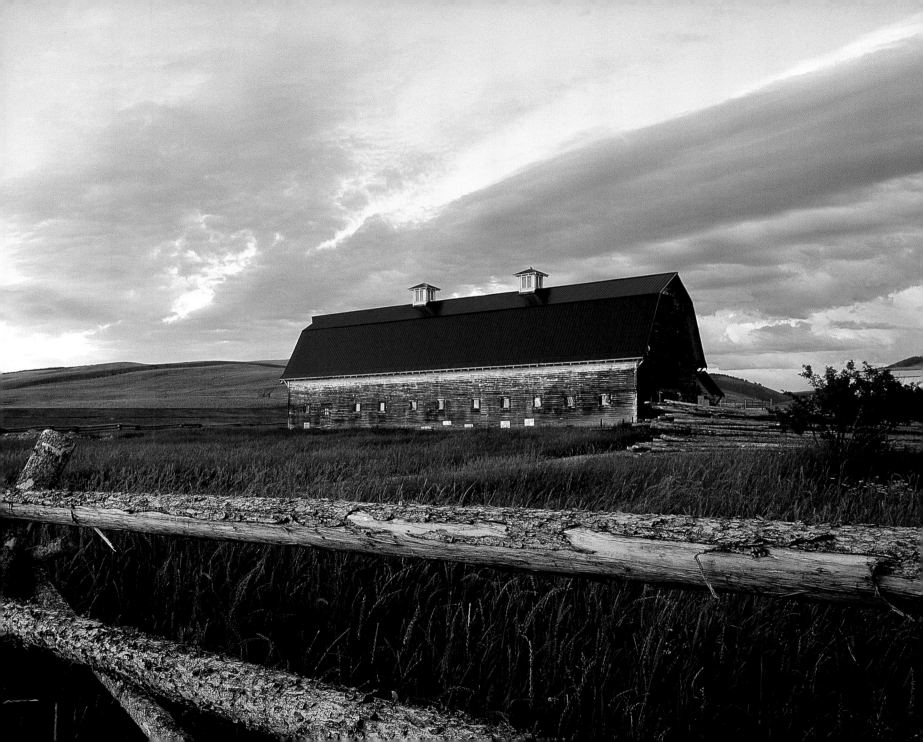

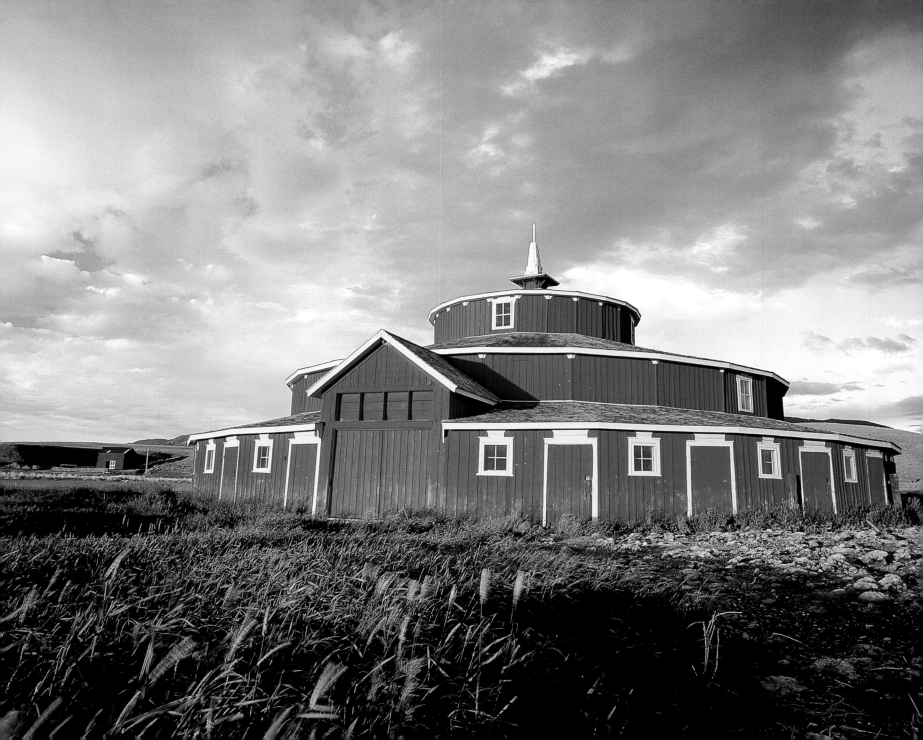

Round Barn

This round red barn is something of a local landmark. Sitting pretty between the Tobacco Root and Highland mountains in the Jefferson River Valley, this unique building has seen considerable activity since being constructed in 1882 by mining entrepreneur, Noah Armstrong.

Armstrong, who was a racehorse enthusiast, believed the thin air of Montana might provide an edge to his horses on the racetrack. In 1886 a horse named Spokane was born in one the barn's stalls, and in 1889 Spokane won the Kentucky Derby, the only Montana horse ever to win that race.

The ground floor of the three-story barn contained horse stalls, offices, and sleeping quarters for employees. A spiral stairway led to the second-floor granary and hayloft; they were capable of holding 12,000 bushels of grain and 50 tons of hay. Up another flight of stairs a 1,000-gallon water tank was filled by a windmill located on top of the barn.

Though the barn remains famous for its racehorses, most of the action in the barn involved cattle. The barn was eventually taken over the Bayers family who became well known for their purebred Herefords. The barn was used as a sales ring, and former owner Byron Bayers estimates that during a span of 48 years more than five million dollars worth of Herefords were sold to buyers from more than 38 states and from as far away as Hungary and Zimbabwe.

Presently the barn is owned by a former Montana resident, Allen Hamilton. Hamilton has real appreciation for historic buildings and hired crews to painstakingly restore the barn to its former glory. Besides leveling up the foundation, the roof was replaced and fresh paint applied.

Travelers can enjoy the unique architecture and fascinating history while passing by on Montana Highway 41. ♦

FACING PAGE: *The grand, historic Round Barn of Twin Bridges, built in 1882*

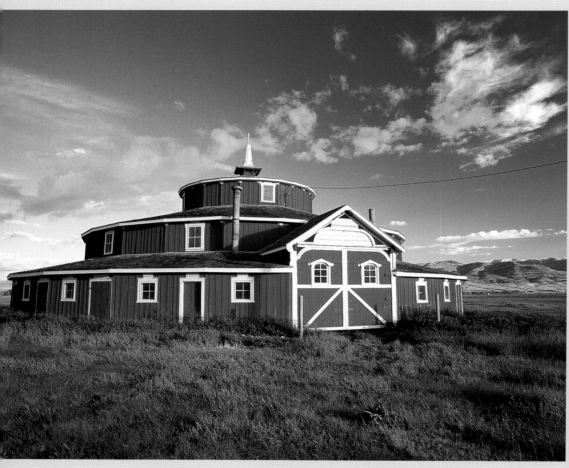

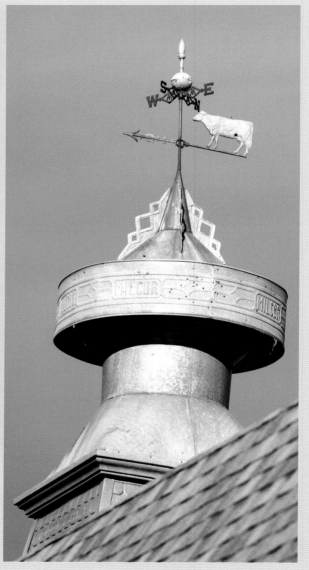

ABOVE: *Another view of the Round Barn of Twin Bridges*
RIGHT: *Cupola on the Ross Fork barn northwest of Lewistown*
FACING PAGE: *Hay bales and the Ross Fork barn*

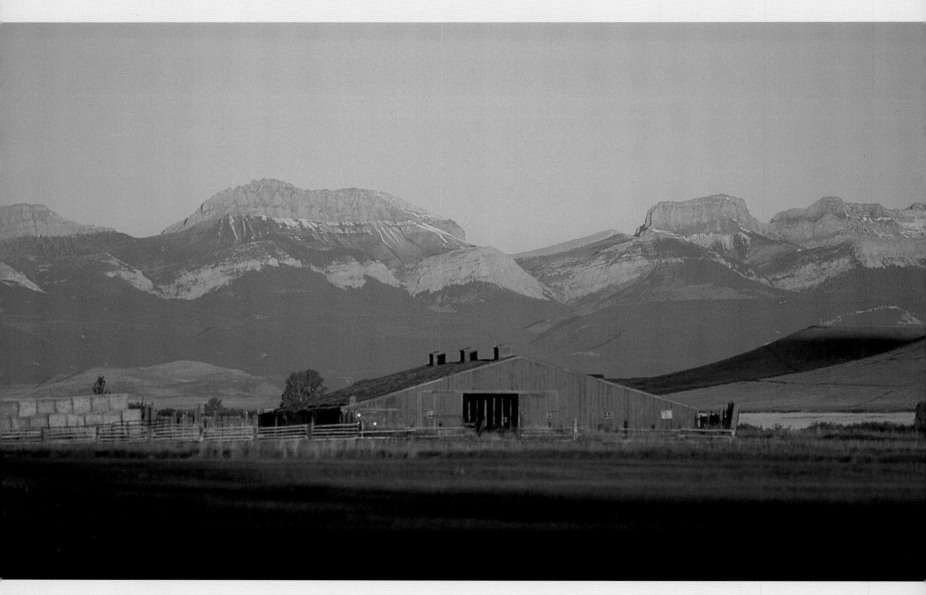

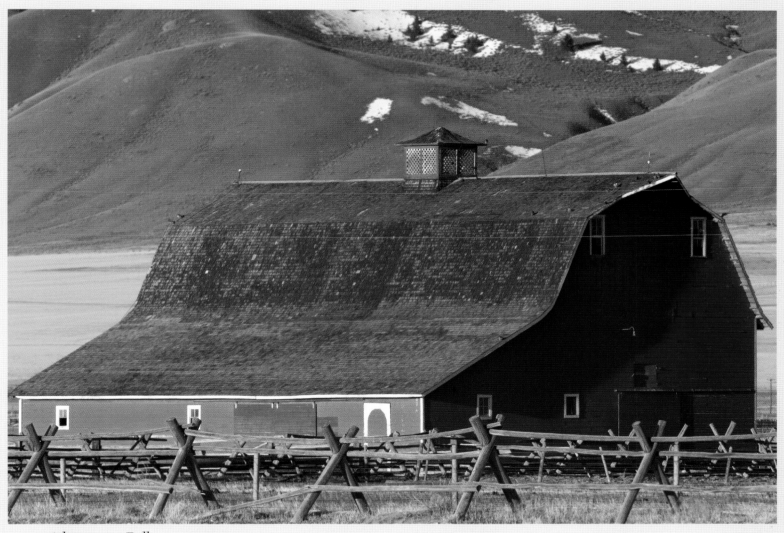

ABOVE: *A barn near Dell*

FACING PAGE: *A stock barn near Choteau and the Rocky Mountain Front*

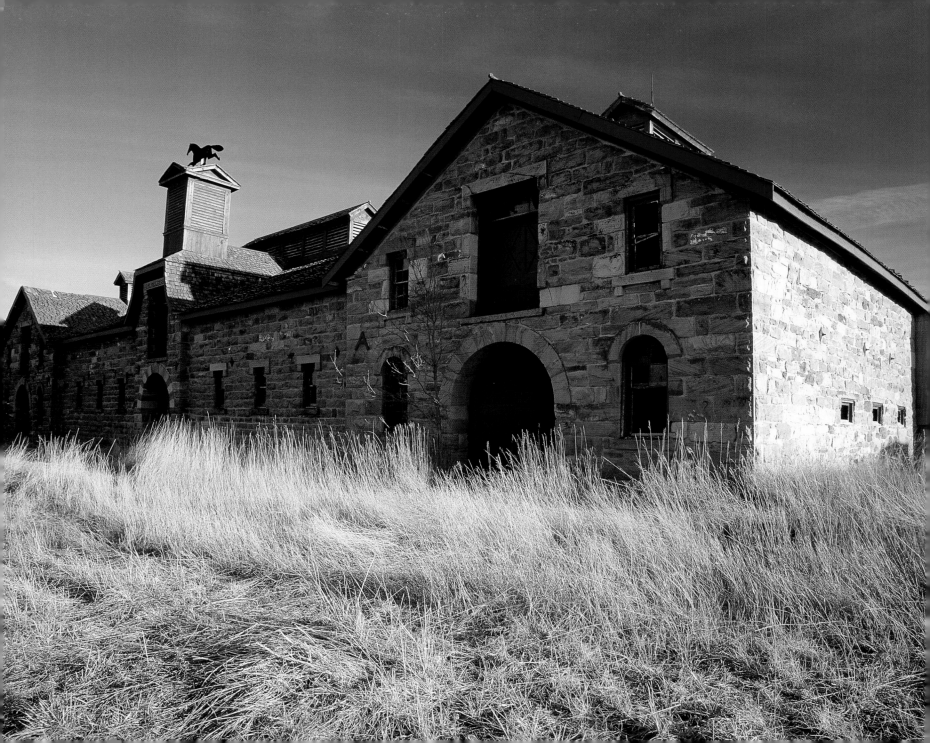

The Stone Barn of Cascade County

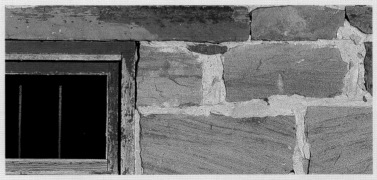

Sitting stoically beneath the Rocky Mountain Front, this distinctive sandstone barn was built in 1885 by wealthy Sun River cattleman, J. C. Adams, who was also the model for the "Wagon Boss" in Charlie Russell's paintings. A writer for the *Los Angeles Times* once described the barn as "the best known barn in Montana."

Adams had moved to Montana in 1864. In 1883 he hired William Bruce, a Canadian, and two Swedish stonecutters to build his 140-by-40-foot barn. The job took two years and reportedly cost $10,000, a huge sum in those days. The stones for the building were cut by hand. The barn was used to help supply livestock to soldiers at nearby Fort Shaw.

The stone barn is said to be the only barn of its kind west of the Mississippi. Romanesque arched doors and 68 arch-framed windows grace the gabled structure, and red paint accents the trim that blends in with the native sandstone. The crowning touch is a life-sized stallion weather vane.

On the main floor of the barn were stalls for Adams' horses, including those he raised for the soldiers at Fort Shaw and racehorses that competed in England. The loft was used

FACING PAGE: *The J. C. Adams Stone Barn, built in 1885*
RIGHT: *Detail of the stonework on the Stone Barn*

to store hay and as a social gathering place for Adams' large family and friends.

The barn changed owners many times. It was later used as a dairy for more than 30 years.

In 1973 a Wisconsin couple discovered the barn shortly after moving to Montana. It was love at first sight for Mike and Teresa Stuckslager. Mike dug into the history of the barn and Teresa tracked down descendants of its original owner. Through Mike's efforts, the barn was placed on the National Register of Historic Places in 1979. ♦

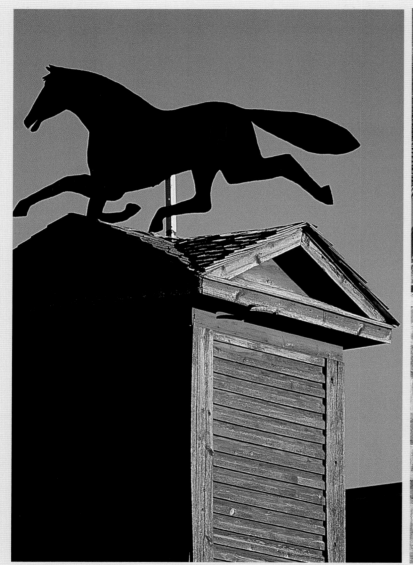
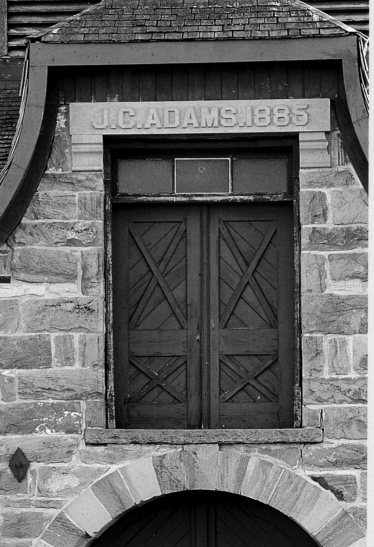

ABOVE: *Shadow on a red barn near Columbia Falls*
FACING PAGE: *Details of the J. C. AdamsStone Barn*

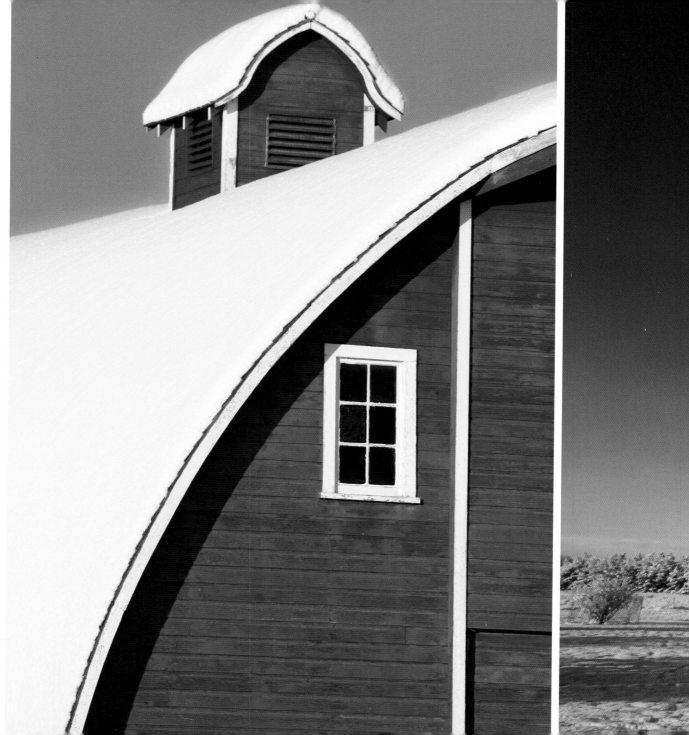

RIGHT: *The Edmiston barn in the Flathead Valley*

FACING PAGE: *A snow-covered mountain ash and the Edmiston barn*

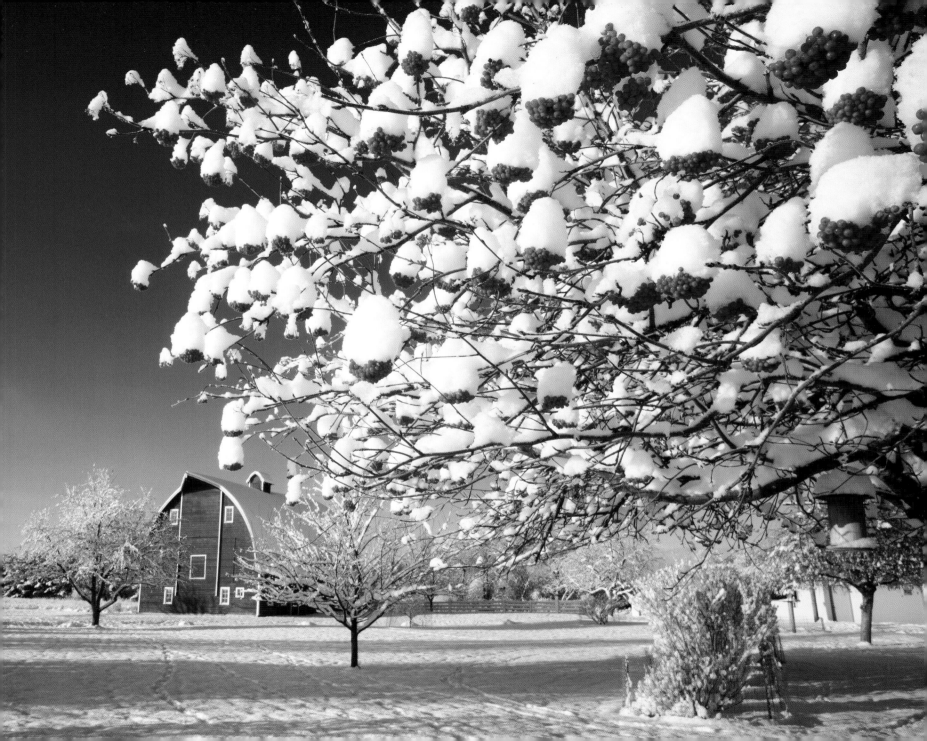

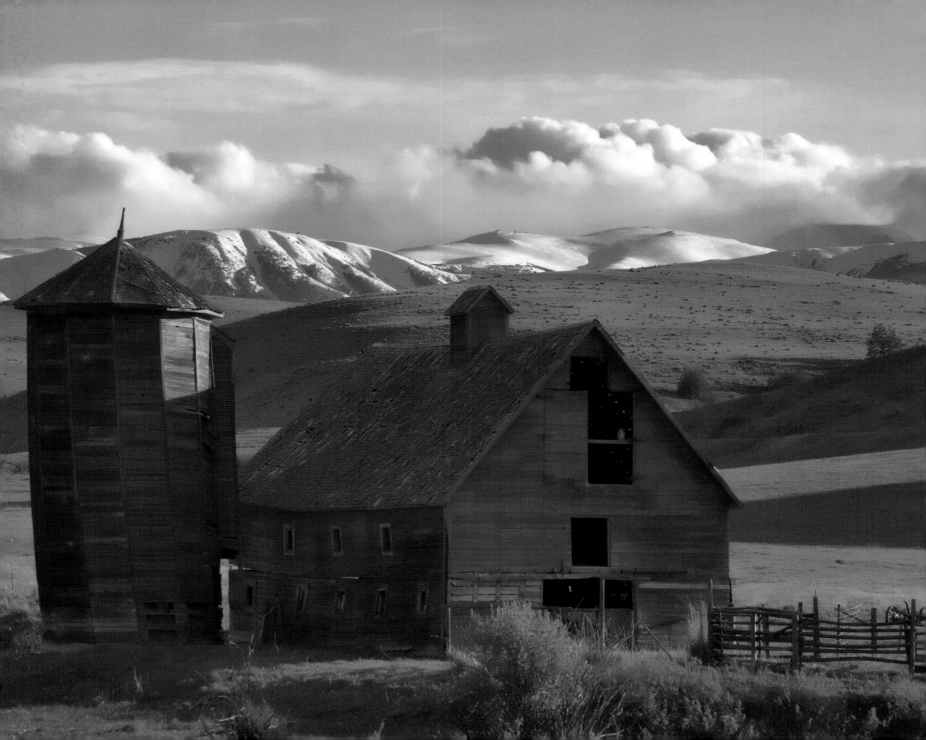

Willow Creek/ O'Shea-Johnson Barn

The idyllic setting of winding Willow Creek and the Beartooth Mountains frames the remnants of the O'Shea-Johnson barn just south of Cooney Reservoir State Park.

Built in the 1910s, the land was once owned by Irish emigrant brothers, Daniel and James O'Shea. A silo was also built to store corn and sunflower silage for a dairy herd featuring the Ayrshire breed, known for its cream production. Cans of cream from the diary was hauled to nearby Roberts and provided a much-needed source of income during the Great Depression. Horses were also kept in the barn as the O'Sheas ran a diversified farm of beef cattle, sheep, dairy cows, hogs, and a variety of grain crops and forage.

In 1913 Daniel O'Shea was elected as a state senator representing Carbon County, and James served three terms as a state representative.

The barn has a concrete footing foundation and a wood-shingle roof. Exterior walls are logs covered by horizontal wood siding. The 12-sided wood silo has a shingled hexagonal roof. If you're lucky you may even spot a great horned owl overlooking the terrain from the hayloft. ♦

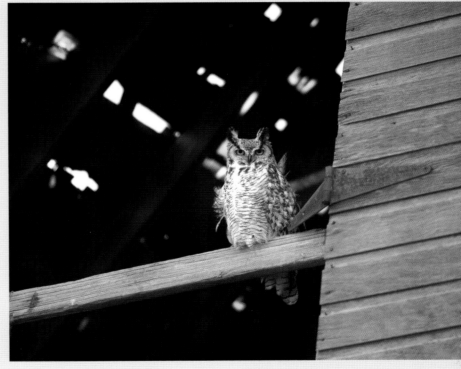

ABOVE: *Great horned owl, a common resident of old barns*
FACING PAGE: *The Willow Creek barn*

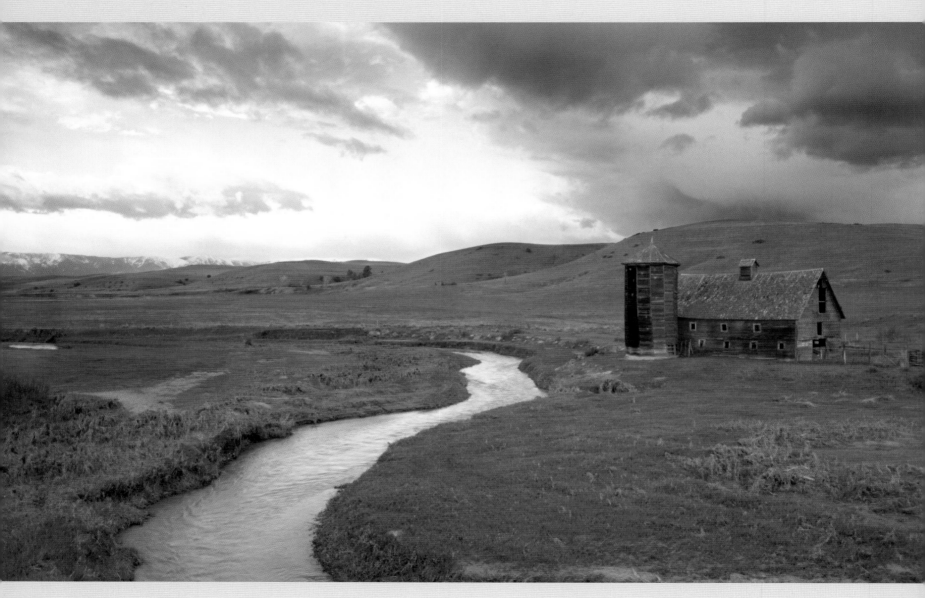

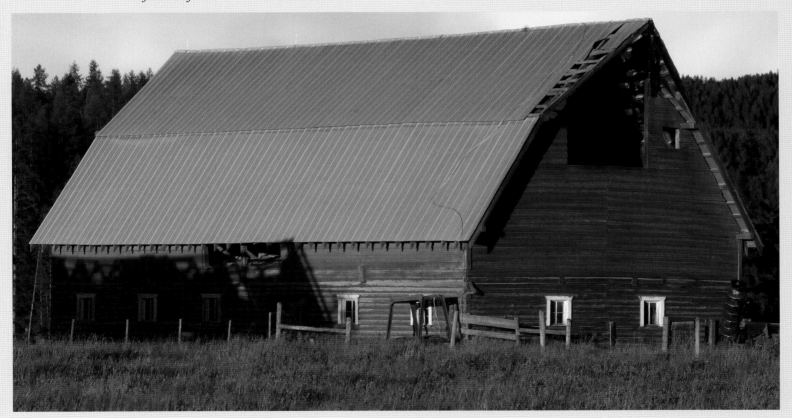

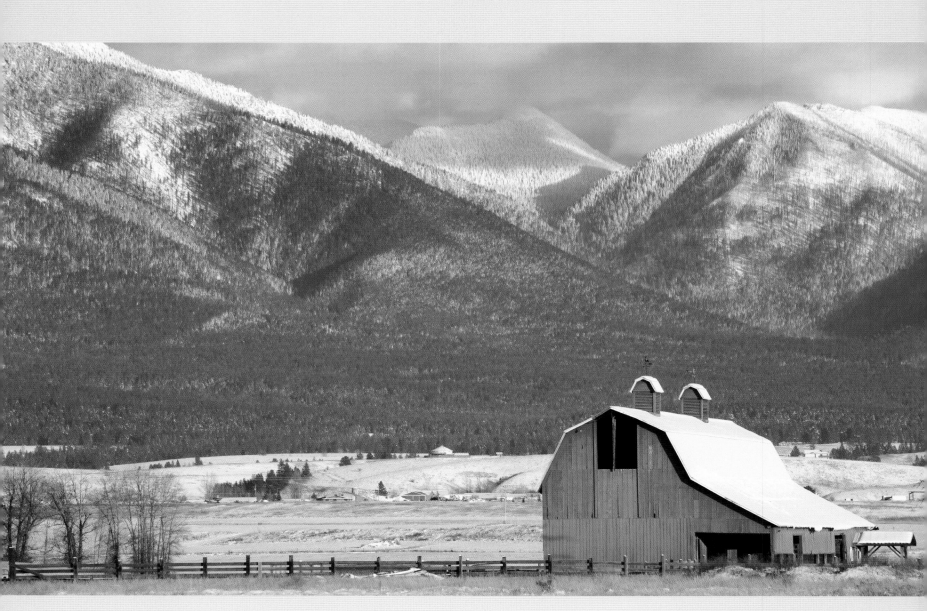

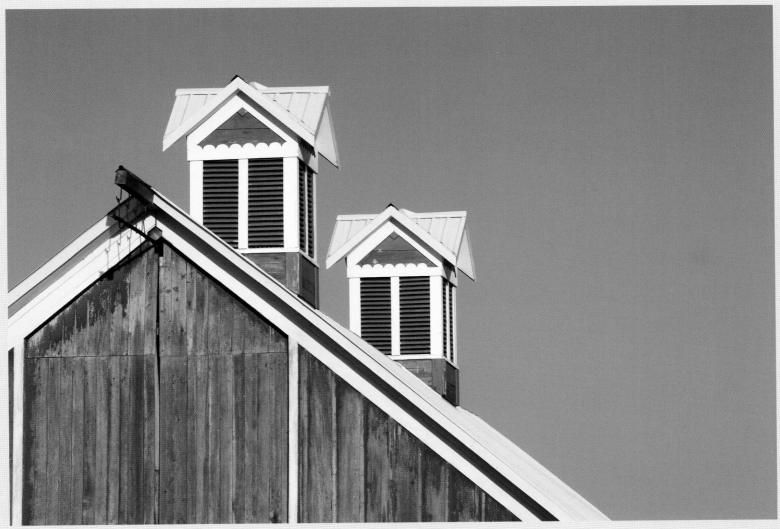

ABOVE: *Intricate cupolas on a barn near Creston*

FACING PAGE: *A barn near Eureka*

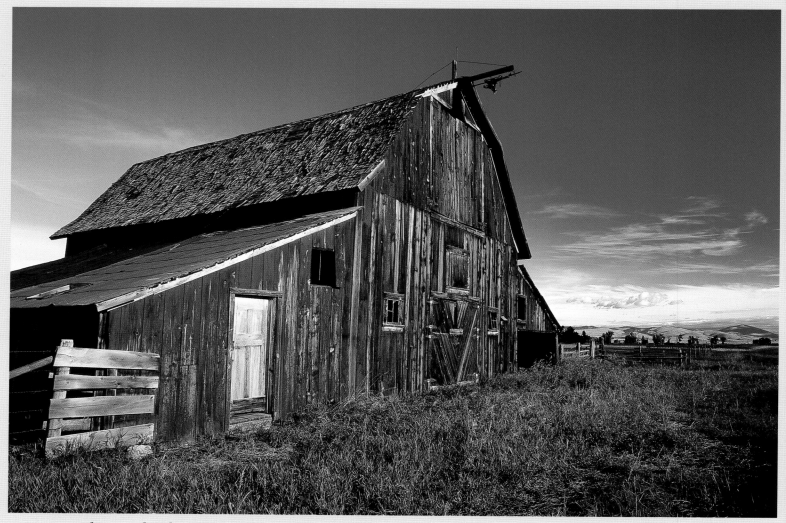

ABOVE: *Rustic barn in the Flint Creek Valley near Philipsburg*
FACING PAGE: *The Majerus barn in the Judith River Valley*

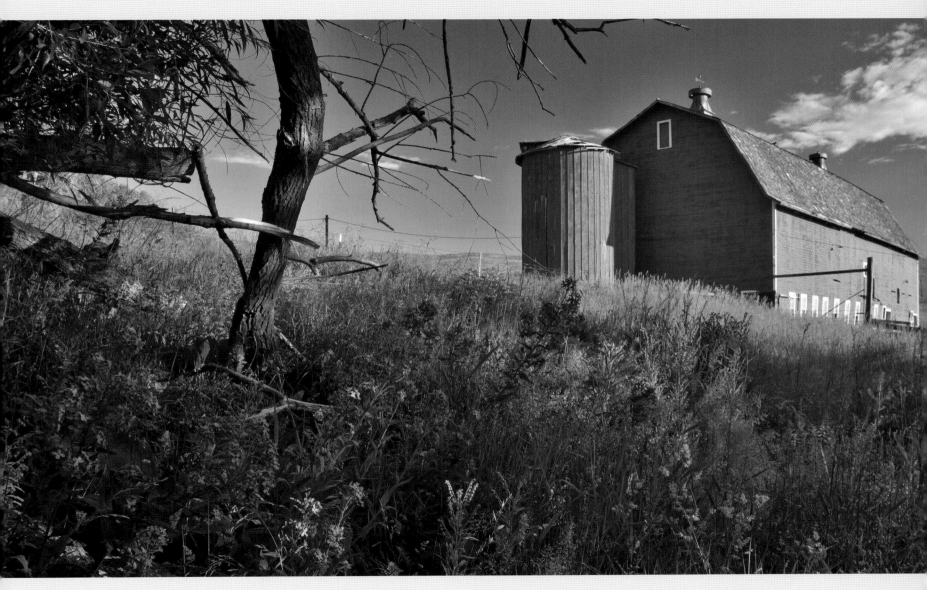

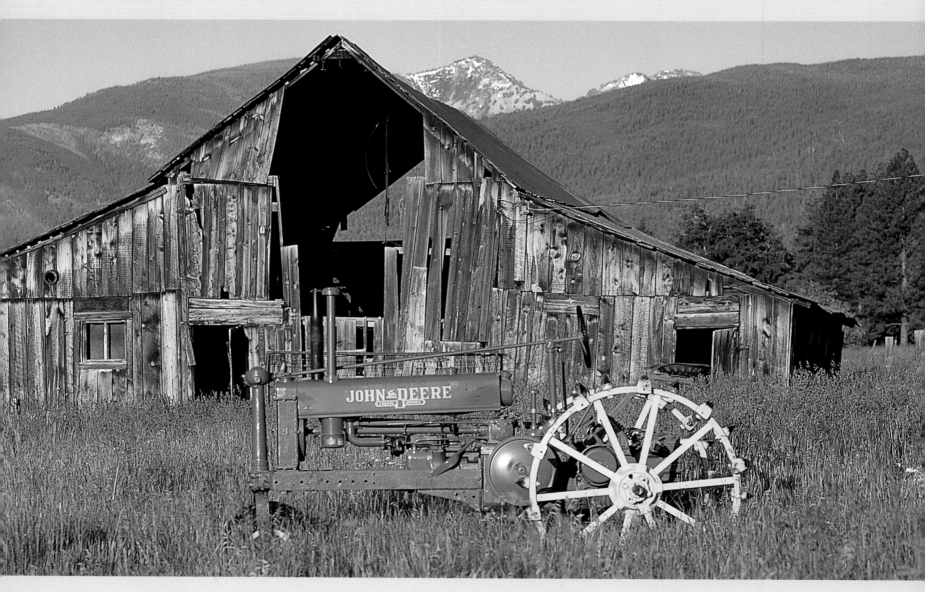

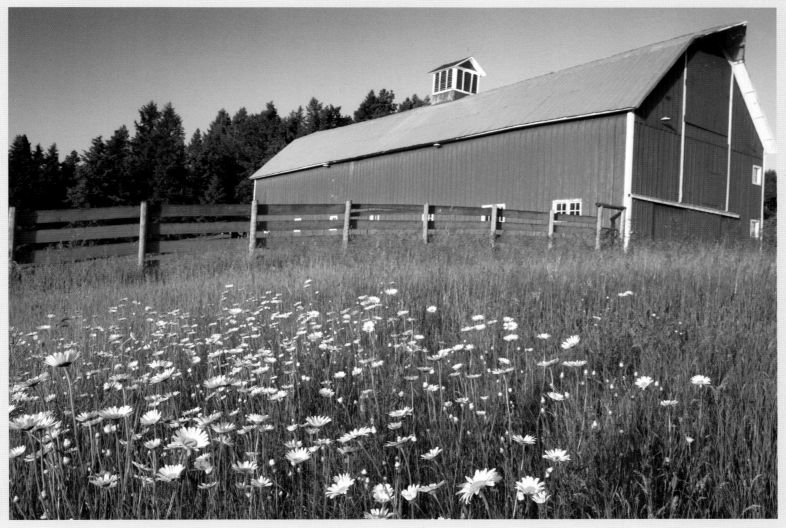

ABOVE: *A barn near Bigfork*

FACING PAGE: *A barn near Hamilton with a 1938 John Deere Long Frame BN Model tractor*

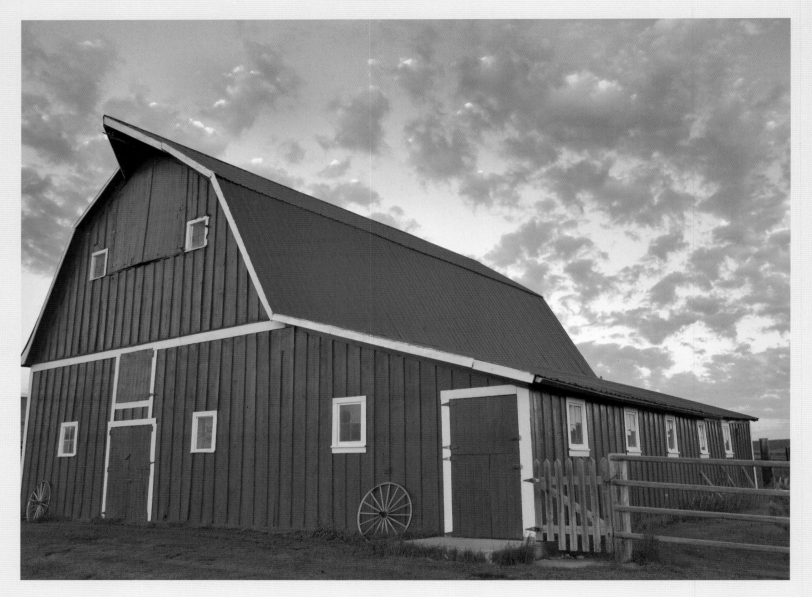

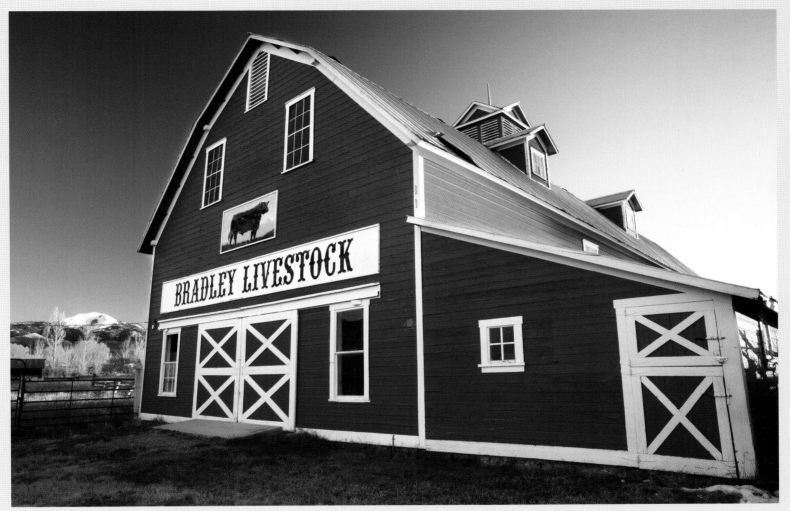

ABOVE: *Bradley Barn near Sheridan*
FACING PAGE: *The old Moseby barn near Lewistown*
FOLLOWING PAGE: *A barn reflecting in the Flathead River with the Swan Range in the background*

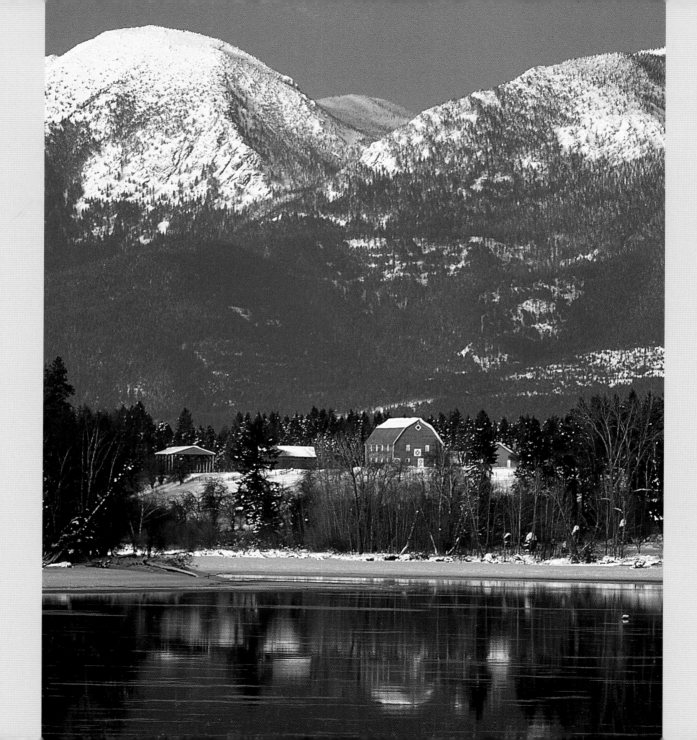